IMAGE
of Amei

PADUCAH

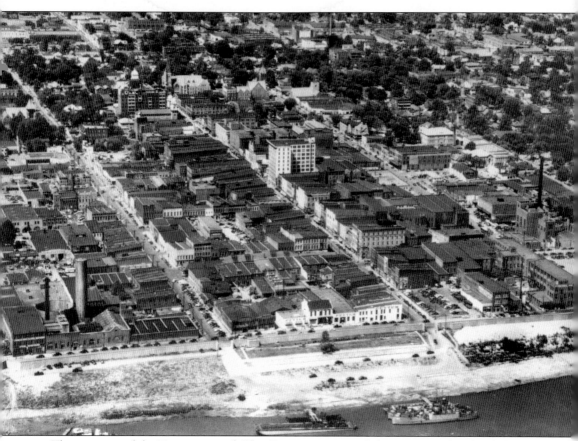

The junction of the Tennessee and Ohio Rivers encouraged the creation of Paducah, but the rivers often proved to be threatening. Floods came with regularity, in 1815, 1822, 1828, 1832, 1867, 1883, 1884, 1913, and 1937. Each event also came progressively higher, from the city's founding in 1830 until 1937, when 20,000 people had to be evacuated. Immediately after the disaster of 1937, work began on a defensive levee system. The completion of the floodwall dates from 1946, when steel gates became available for installation. This system, plus the construction of new dams allowing improved flood control on the Ohio, Tennessee, and Cumberland Rivers, keeps the rivers in their place as long as the pumps work. Note that the removable gates are in place in this 1956 view. This was necessary in case the rivers rose above 49.5 feet. The last such occurrence was in March of 1997.

Cover photograph courtesy of W.L. "Dub" Beasley Jr.

IMAGES
of America

PADUCAH

John E.L. Robertson

ARCADIA

Published by Arcadia Publishing
Charleston SC, Chicago IL, Portsmouth NH, San Francisco CA

Printed in Great Britain

Library of Congress Catalog Card Number: 2004104920

For all general information contact Arcadia Publishing at:
Telephone 843-853-2070
Fax 843-853-0044
E-mail sales@arcadiapublishing.com
For customer service and orders:
Toll-Free 1-888-313-2665

Visit us on the internet at http://www.arcadiapublishing.com

CONTENTS

ACKNOWLEDGMENTS

Walter L. Beasley Jr. graciously allowed access to his large collection of annotated and organized photographs; they proved to be a pleasure to work with and invaluable to this book. Vonnie Shelton, special collections librarian at the McCracken County Public Library, again helped identify, reference, and photograph materials in that depository. In particular the Steinhauer holdings are strong on flood scenes. Without the help of the following this undertaking would not have been possible: J. Sam Jackson, the Paducah Board of Education, Mary Hammonds, Rosemarie Steele and the Paducah Tourist Bureau staff, Sue Reid Draper, W.O. Green, Jim Keeny, Jim Hank, Bertha W. Wenzel, Gail Ridgeway, Elizabeth Brown, Loudell Paul, Shirlene Mundy, Edward Leek, Bill Black Jr., Jack Johnston, Robert Johnston, Robert Dafford, James Curtis, personnel at various churches, the Blalock and Stacey families, Tom Emerson, Phyllis Ham, Thomas D. Galvin, the Joe H. Metzgers, Ann Lou Shaffer French, the River Heritage Museum, Ro Morse, Doug Van Fleet, *The Paducah Sun*, Barron White, and others.

References are from my books, plus the 1979 reprint of Fred G. Neuman, *The Story of Paducah (Kentucky)*, Image Graphics, 1979; Camille Wells, *Architecture of Paducah and McCracken County*, Image Graphics, 1981; Donald E. Lessley, *Paducah: Gateway, A History of Railroads in Western Kentucky*, Troll Publishing Co., 1978; and *Kentucky Encyclopedia*, ed. John E. Kleber, the University Press of Kentucky, 1992.

Finally, without my wife Margaret, I would never accomplish anything of value.

INTRODUCTION

Paducah is a paradox. George Rogers Clark first noted the site of the town at the juncture of the Tennessee and Ohio Rivers during the American Revolution, and his younger brother William, of Lewis and Clark fame, founded Paducah on April 27, 1827. Paducah came into being to exploit river commerce, but by 1860 railroads grew in importance, and they remained the major employer up to 1950. Flooding forced the McCracken County government to move from Wilmington to Paducah in 1832, even though the town was on the extreme edge of the large county. Gradually, the size of the county was reduced as Ballard and Carlisle were formed; Paducah became a third class city in 1856, based on population as defined by the Constitution of Kentucky in 1891. Late in 1861, Paducah, partisan to the South, found itself occupied by Union forces that remained throughout the war. Confederate general Nathan Bedford Forrest raided Paducah twice in 1864. Federal authorities retaliated by putting heavy restrictions on those in the community who favored the Confederate cause. Some civilians were expelled to Canada. With peace, former slaves and former rebel soldiers had to be integrated into the social and economic life of the community; this was done quickly and quietly despite problems. In general, before 1916, African Americans were present but unseen. The community recovered and experienced a spurt of growth that allowed it to become one of four cities of the second class in the commonwealth by 1902.

By 1913, visitors often associated the city with vice and pleasure. A concerted campaign to eliminate prostitution swept the city just prior to World War I. "Drummers" from Paducah ranged throughout the surrounding states, and the town continued to grow as a break-in-bulk point for river traffic and as a midpoint on railroads running from Louisville to Memphis and from Paducah south over the New Orleans and Ohio Line that connected Paducah to New Orleans and Mobile. Before 1937, Paducah was considered high and dry, for the most part; the great flood of that spring altered that view. Growth slowed, due in part to the Depression, World War II, and the out-migration of many Paducahans in the late 1940s. The location of the gaseous diffusion plant near Paducah gave the sleepy city a jump-start as its population doubled nearly overnight in early 1950—Paducah redefined itself with little or no outside help.

Today merchandising has moved to the western edge of Paducah while the old downtown section continues to reinvent itself. The city is a regional retail and medical center, aided by its location on interstate highways midway between St. Louis and Nashville and between Chicago and New Orleans. River industries are regaining importance, aided in part by the linking of the Ohio and Tennessee Rivers with the Gulf of Mexico via the Tombigbee canal. Streams of teeming people participate in various events that pack the streets during summer, especially on weekends. Paducah houses a world-class museum dedicated to quilting and folk art. Thirty thousand visitors or more attend the annual Quilt Show. The award-winning Artist in Residence program produced a creative cadre now attracting attention to Paducah as a breeding ground for the fine arts and various crafts.

Education is valued in Paducah. An African-American teacher-training college started in 1910 and continued until 1937. For a time, it was one of the largest African-American two-year colleges in the nation. In 1932, when the nation was in the worst of the Great Depression, Paducahans created a white, private, two-year liberal arts school that charged higher tuition than the University of Kentucky. Later it received tax support and became Paducah Junior College (PJC). In 1965 PJC merged into the new community college system of the University of Kentucky. Today the two schools are combined into West Kentucky Community and Technical College. Located on the same campus is part of the Engineering College of the University of Kentucky, offering accredited bachelor's degrees. NASA also has a space center designed to acquaint area elementary, middle, and high school students with advances in science and technology. Schools with K–12 programs in Paducah, both public and private, rank high in the state in achievement. In sports, Paducah Community College won the national junior college basketball championship in 1965. Paducah Tilghman High School, like its predecessor Augusta Tilghman High School, enjoys an enviable record in sports, especially track and football. St. Mary parochial high school produces excellent cross-country runners.

Paducah is small in size but hosts a boys' choir that exchanged visits with the famous Vienna Boys Choir. The local symphony continues to earn a reputation for excellence. A community band performs for events on the riverfront during the summer. Paducah Community College, Tilghman, and St. Mary host and present a varied mix of music and theater. The college also has the local cable TV station, Channel 2, which serves over 20,000 and produces award-winning programming. The opening of the Luther Carson Four Rivers Performing Arts Center on the banks of the Ohio River in 2004 inaugurated a slate of performances by world-famous artists and troupes. The Maiden Alley Cinema Theater downtown specializes in limited-release films, while the rebirth of the Columbia and Arcade Theaters gives Paducah additional opportunities for the revitalization of the downtown area as a center of entertainment.

The recent admission by the federal government that the uranium enrichment plant just west of Paducah poses a health risk brings out in the open the assertions of many area residents. Work to clean up the site progresses rapidly. Both Paducah and Piketon, Ohio, seek to have the new technology located there; however, Piketon has a plant previously used for gaseous diffusion but designed specifically for the new centrifuge separation technology. The choice of Piketon on January 13, 2004, bodes ill for the future of Paducah.

One

BEGINNINGS

1830–1865

In 1818, Isaac Shelby and Andrew Jackson made a treaty for the United States with the Chickasaw for all lands between the Tennessee and Mississippi Rivers in what is now Kentucky and Tennessee. This became known as the Jackson Purchase as Jackson did most of the work. Platted by William Clark in 1827, Paducah became a village in 1830. Its location on navigable rivers helped the community prosper and grow to become a third-class city by 1856. The New Orleans and Ohio Railroad ended at Paducah and was operational by 1860, as was a telegraph line. Fires, storms, and the Civil War all impeded the continued growth of Paducah until 1865. The first independent decision of Gen. U.S. Grant was to seize Paducah in 1861 in retaliation for the Confederates taking Columbus and Hickman the day before. Occupied throughout the war by Union forces but having a strong sentiment for the South, Paducah was at times persecuted by the occupiers. In 1862, General Grant expelled all Jews from his command. Caesar Kaskel and others who were forced to leave Paducah stopped at Cincinnati and got Congressman J.A. Gurley of Ohio, then went directly to President Abraham Lincoln, who had the order rescinded. After two raids by Confederate Gen. Nathan Bedford Forrest 1864, federal authorities instituted a "Reign of Terror" against those suspected of supporting the rebels. Several Paducah families were sent to Detroit and expelled to Canada for disloyalty. Peace raised the issue of how to treat former slaves and former members of the Confederacy.

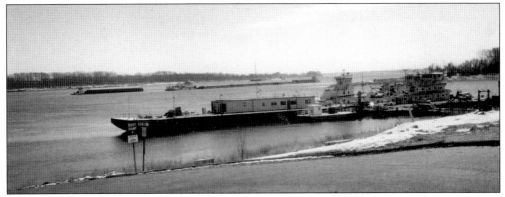

The Ohio River, on the left, receives the Tennessee River, on the right, at Paducah. William Clark, in a letter to his son Meriwether Lewis Clark in 1827 from St. Louis, reported he named the town to honor the memory of a once-proud tribe, the Padouca, which had lived here but moved westward and was decimated by contact with European culture.

9

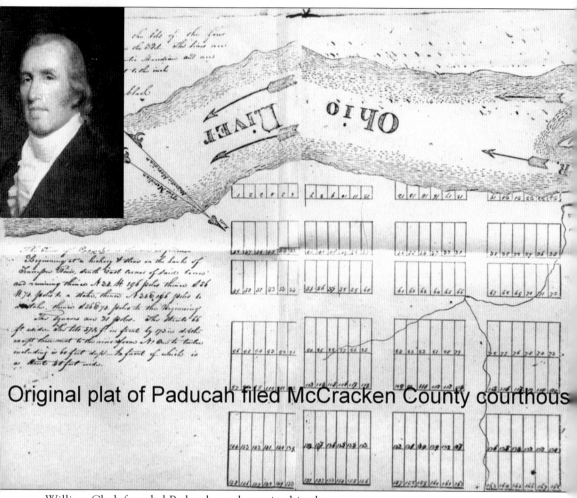

Original plat of Paducah filed McCracken County courthous

William Clark founded Paducah, as shown in this plat.

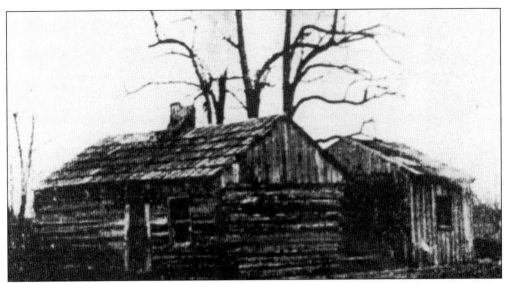

This log structure built by the Pore brothers about 1830 was one of the first residences in the new village. Early on, the town appointed inspectors to insure that these wooden cabins were not fire hazards. Chimneys had to pass a safety test. Fires, especially one in 1850, almost wiped out the new town. The city acquired "hooks-and-ladders" to cope with this threat.

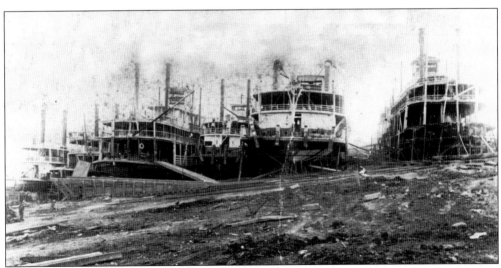

Use of the riverfront was closely supervised. Rental of space to stack wood for refueling steamboats proved a source of income for the new community. Later, repair facilities such as this one made Paducah a vital port on the inland waterway. Before dams improved navigation, many families of boat personnel "wintered" in Paducah. In 1847 the federal government built a "marine" hospital to serve crews on the various boats.

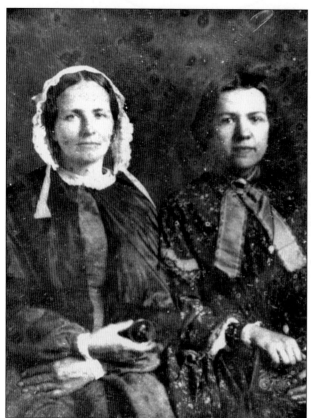

This tintype shows two of the first settlers of Paducah: Mary Kirkpatrick, who married R.S. Radcliffe, and sister Margaret, who married John F. Harris; the sisters were from one of Kentucky's pioneer families. Natives killed their father Moses near what is now Louisville. About 1830 the family moved to the mouth of the Tennessee. The sisters died in 1843. Note the picture one holds.

Currently the Alben Barkley museum of the Paducah Young Historians Association, this Greek revival structure was built in 1852 by Capt. William Smedley, who dealt in marine supply and was part owner of the *Excelsior* wharf boat. Later, the cottage was the home of long-time mayor David A. Yeiser. During one of the terms of Mayor Yeiser, the city got its charter to become one of four second-class cities in Kentucky.

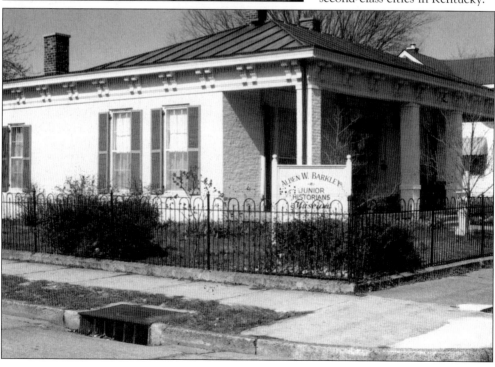

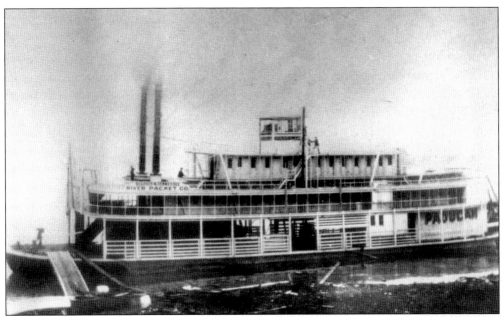

Large steamboats from the Mississippi and Ohio Rivers often stopped at Paducah to offload cargo destined for communities on smaller rivers such as the Cumberland and Tennessee. Packet steamers, such as the *Paducah* shown here, drew less water and could serve remote settlements on the Tennessee and pass the rapids at Eddyville on the Cumberland and thus get to Nashville and further South.

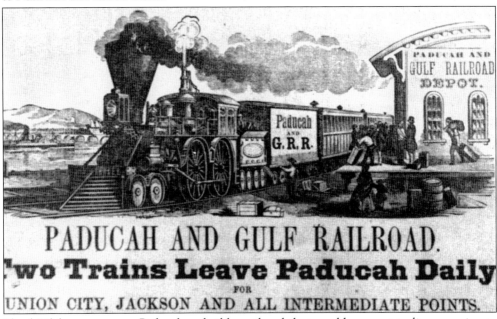

Lloyd Tilghman came to Paducah to build a railroad that would connect to lines running to Mobile and the Gulf. A member of a prominent Maryland family, Tilghman was a graduate of West Point and served in the Mexican War. Leaving the army, he was active in railroad construction in the United States and Panama. The New Orleans and Ohio was opened in 1860. Later, Tilghman was a Confederate general.

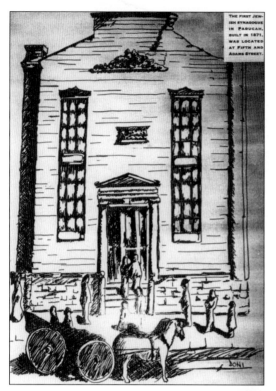

THE FIRST JEW-
ISH SYNAGOGUE
IN PADUCAH,
BUILT IN 1871,
WAS LOCATED
AT FIFTH AND
ADAMS STREET.

Germans and German Jews in Paducah made it more cosmopolitan than other parts of the Purchase region. This region firmly supported Jackson's Democratic Party while Paducah often voted Whig or even Know Nothing. The temple in Paducah reflected the reformed movement in Judaism, associated with the Cincinnati area. Jewish leaders in Paducah included Caesar Kaskel, who convinced President Lincoln to rescind Grant's order expelling Jews from his command in 1862.

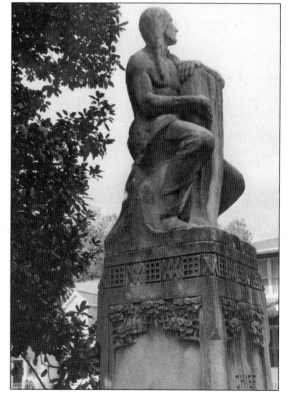

This monument to a man who never was is the statue carved by Lorado Taft of Chicago for the D.A.R. in 1909. According to the legend, Paduke was a sub-chief of the Chickasaw Nation and was a personal friend of William Clark. Paducah adopted this legend as the totem of the city and the image helped civic leaders publicize the community. Chickasaw chieftains were designated *mingo*, like Piomingo.

14

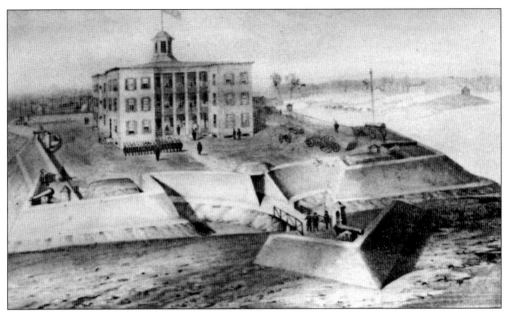

In 1847 the federal government built a "marine" hospital to serve river workers. After Grant took Paducah in September 1861, the structure burned and was replaced with an earthen redoubt that served the garrison in 1864 when Nathan B. Forrest raided the city twice. Two gunboats, *Peosta* and *PawPaw*, aided the Union forces. Union authorities later punished those who gave support to the Confederacy in a "Reign of Terror."

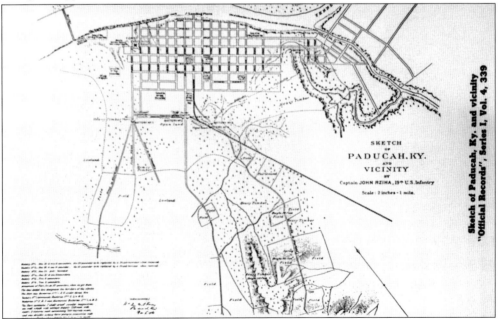

Riza's map of the fortifications at Paducah illustrates the proposed defenses for the city. Not all sites were completed or manned. On March 25, 1864, a column of rebels, part of D company of the 3rd Kentucky Regiment, advanced on the fort, led by A.P. Thompson, who was killed in the attack. Many of the raiders were from Paducah and some of their former slaves were among the federal troops.

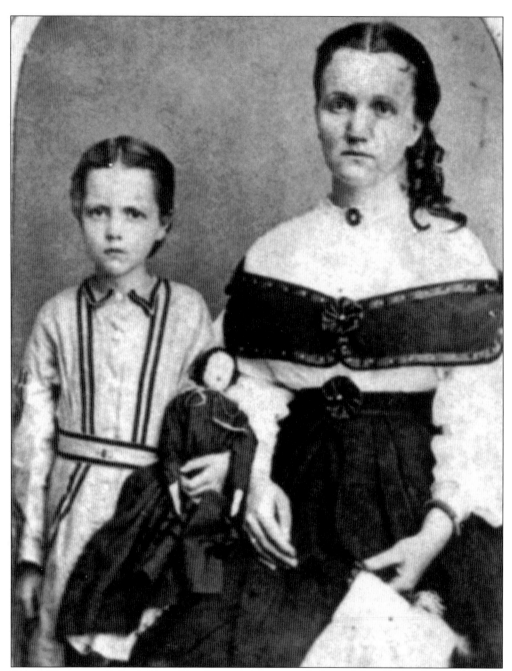

For civilians, especially children like the two girls pictured above, life in Paducah went on until the two raids by Confederate Gen. Nathan Bedford Forrest in 1864. A young staff officer from Michigan attached to Gen. E.A. Paine, perpetrator of the Reign of Terror against civilians favoring the rebellion, reported going to Broadway Methodist Church hoping to meet some local belles. He told his mother that the young ladies wore gray, red, and white, but none wore blue. Paine displaced some more notable leaders and their households to Detroit, escorted by African-American soldiers of the 12th Heavy Artillery (Colored). Later, Paine faced a court martial, but being a friend of Lincoln, he was acquitted.

When Leonidas Polk took command at Memphis, Kentucky's neutrality ended. Polk undertook to seize the high ground at Hickman and Columbus to block traffic on the Mississippi River. U.S. Grant, commanding at Cairo, Illinois, countered by landing in Paducah early the next day. This event was reenacted in 2003 with Mark Wood (left), Randy Knight (center), and Mary Hammonds (right) playing General Grant, Mayor John W. Sauner, and Sauner's wife, respectively.

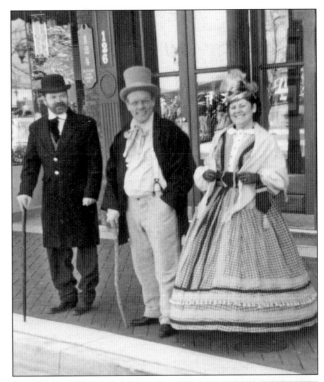

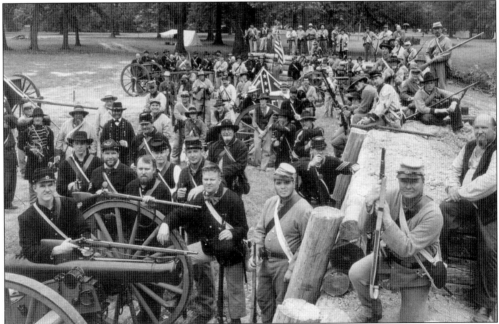

Along with the revival of community activities along the riverfront, Paducah experiences a growing interest in the events during the War of the Rebellion, called the Civil War by most here. The two attacks by Confederate generals Forrest and Buford in 1864 are collectively called the Battle of Paducah although they were only raids. Re-enactors shown here in 2003 conducted a two-day event to commemorate the skirmish at Paducah.

Ladies had their hands full in Paducah after Shiloh. Churches, schools, and empty buildings became makeshift hospitals to handle the flood of wounded that came upriver. Nuns from the local St. Mary's School also volunteered to serve. One church had its pews put under trees to accommodate the wounded.

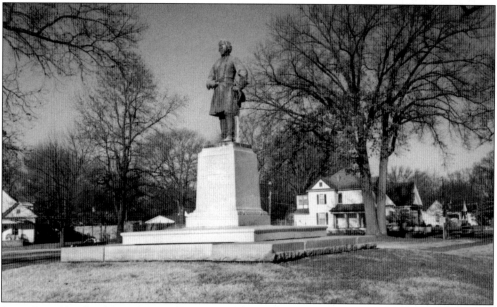

Brig. Gen. Lloyd Tilghman left Paducah for the Confederacy in 1861. At Guthrie, Tennessee, Tilghman formed the 3rd Kentucky Regiment. Later he was given command of Fort Henry, guarding the Tennessee River at the Tennessee state line. Early in 1862, U.S. Grant began the move up the Tennessee and Cumberland Rivers that eventually split the South. Tilghman was the first Confederate general to surrender a fortified position to Grant

Two

GROWTH
1865–1913

Paducah suffered a recession immediately after the Civil War, but with the able administration of Mayor Meyer Weil the city recovered. Expansion of the railroad in the 1870s positioned Paducah midway between Louisville and Memphis on the Illinois Central Railroad. Repair shops located here continued to grow until Paducah had one of the largest facilities in the world by 1927. Population growth enabled Paducah to become one of four second-class cities in Kentucky by 1900.

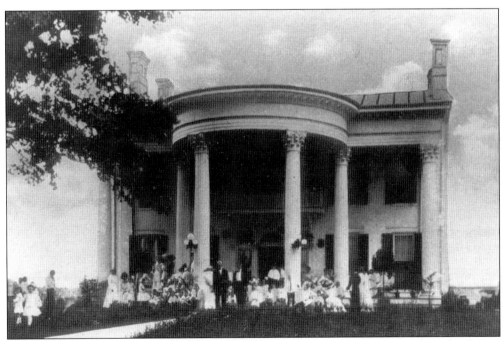

Called "Bide a Wee" after 1907 by the Scottish wife of Mayor James P. Smith, Whitehaven welcomes travelers on I-24. Built before the Civil War, it was the home of the Anderson family, relatives of Robert Anderson, who commanded Fort Sumter at the beginning of the Civil War. In the 1950s the structure was to be razed, but Gov. John Young Brown Jr. redeemed it.

The end of the Civil War meant that Paducah had to regroup and get on; white women, like the girl pictured to the left, waited for their men to return, and Confederate veterans were welcomed and returned to leadership positions in the city. Charles Reed fought for Forrest at Fort Anderson but later became a long-serving mayor. The sentiments expressed became progressively more Southern in Paducah. A Cincinnati newspaper noted in 1868 that Kentucky chose to join the Confederacy.

Freed slaves had to earn a place in society. By 1871 they could vote, but many, such as Ellen Cartwright, pictured here, were not equal. Jobs were scarce and usually limited to domestic employment. Washington Street Baptist Church began in 1854 with a white pastor for the slaves. Freedom led to voluntary segregation of religion at the initiation of the African-American community. This worship practice still remains common.

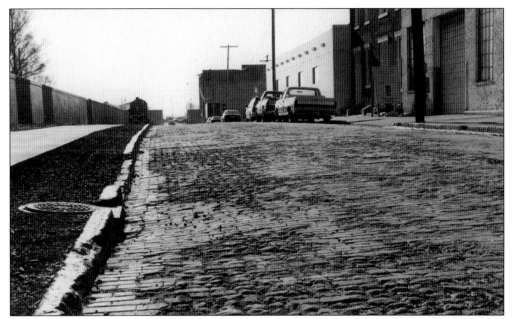

Early Paducah streets often had hogs wallowing in deep holes prior to 1850, and several small ponds were located near the river as well. By 1847 streets near the river were improved. A variety of materials were used, ranging from wood blocks (to dampen the noise) to brick. Today Water Street has returned to its original brick surface. For years, this was covered to "modernize" the business core.

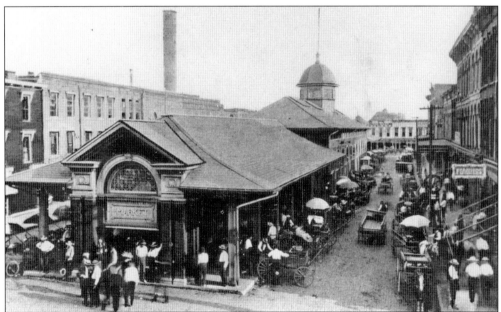

Many remember the Market House as the symbol of Paducah. William Clark designated a site for a town market, and on August 6, 1836, the town finished its first frame market house that served until 1850. W.L. Brainerd designed the present building in 1905; its place as the center of produce sales continued until the 1950s. By 1960 the structure was rescued and converted into the multi-use facility of today.

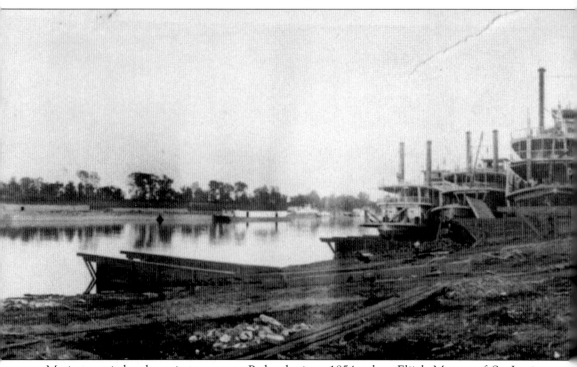

Marine repair has been important to Paducah since 1854, when Elijah Murray of St. Louis completed the first boat repair facility capable of handling barges and towboats up to 350 feet

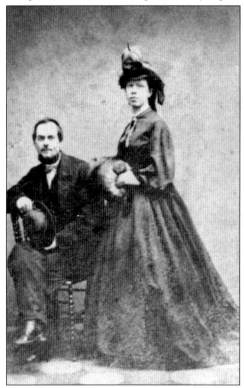

By 1870 Paducah prospered, allowing citizens like these to enjoy myriad products available due to the favorable location of the city on rivers and rails. Fresh oysters arrived from the Gulf by rail. Entertainment came from companies such at those appearing at Morton's Opera until it burned in 1900. The Kentucky Theater presented Lillian Russell, Otis Skinner, Eva Tanguay, Al G. Field's Minstrels, and John Philip Sousa.

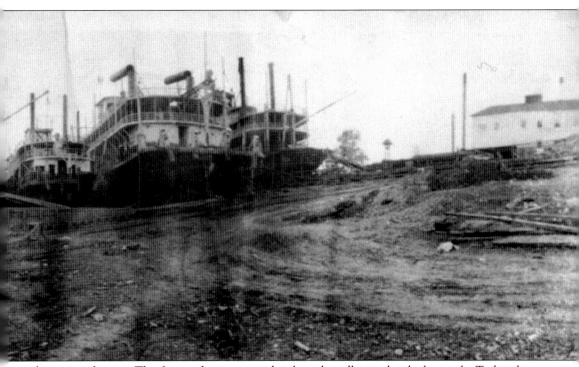

long out of water. The first such system used rails and cradles to dry-dock vessels. Today the riverfront continues this tradition of service to the towing industry and its equipment.

Bicycles evolved from a fad to a rite of passage from childhood into adolescence for many young boys belonging to more affluent families in Paducah prior to 1900. Bikes could be useful if one strayed into areas with a reputation for containing gangs of tough young boys who resented intruders from affluent areas. Each area had its own school, contributing to this departmentalization of city population.

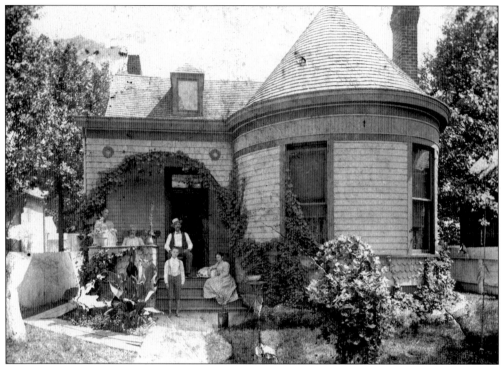

The Reid House at 2304 Broadway was the summer home of one of the pioneer families of McCracken County. Pictured are, from left to right, Mrs. Charity Cox Reid, her father James McIttenny Promeroy Finley, her husband Thomas Jefferson Reid, young John Randolph, and her sister Lena. Note that the expectant Mrs. Reid discreetly positioned herself behind a friendly urn. At the time it would not have been deemed proper to call attention to her condition.

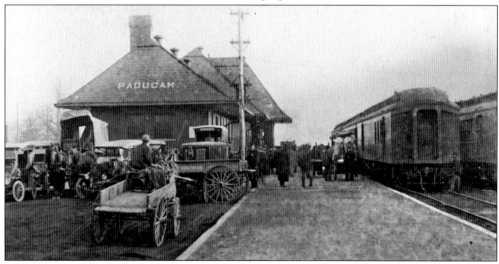

Completion of a railroad from Louisville to Memphis and its purchase by the Illinois Central was finalized in 1896. Paducah became a midpoint on the Kentucky Division with repair shops and administrative offices. Union Station, shown here, also had service running from it to Nashville over the Nashville, Chattanooga, and St. Louis Line. The Paducah and Illinois Bridge, built in 1917, brought in the Chicago, Burlington, and Quincy Line.

The location of foundries near the river downtown made it possible for repair work to be readily performed on river craft. The Jackson Foundry began in 1864, merged with Lining from 1880 until 1888, and became Jackson Foundry and Machine Company until the 1937 flood. As time passed, many felt compelled to "modernize" by "slip covering" these ornamental castings. These facades are now reappearing and being restored.

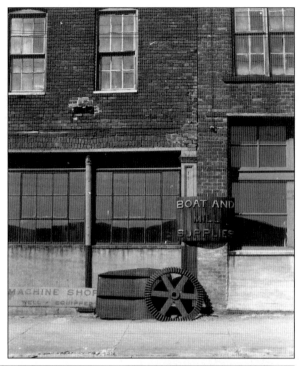

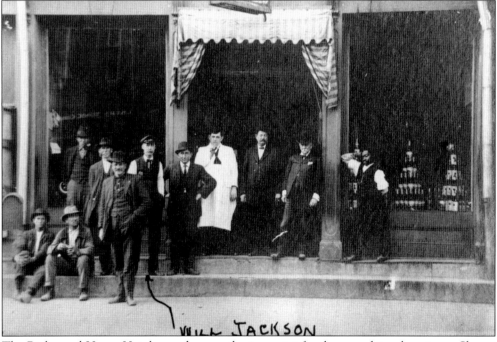

WILL JACKSON

The Richmond House Hotel served as a gathering point for those working downtown. Shown here is Will Jackson of the Jackson Foundry and Machine Company with a group of his companions. Will supervised the work in the shop while his parents managed paperwork in the office. By 1925 the four-story brick structure at First and Broadway had transformed into a "flop" house in a degenerating neighborhood.

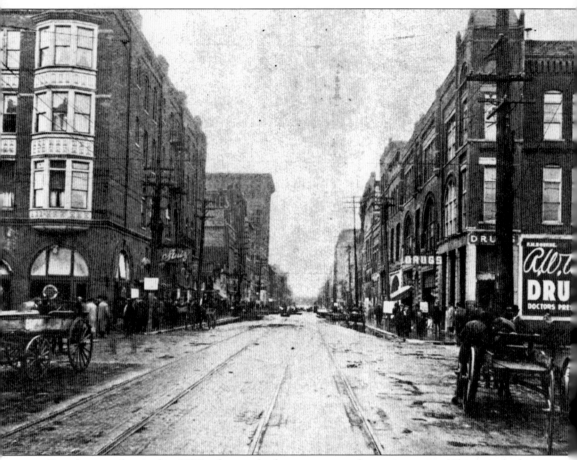

Broadway modernized in 1872, when mule-drawn streetcars began operation. This view looking toward the Ohio River shows the pride of Paducah, the Palmer House Hotel, on the left. Inside was Boswell's Restaurant, the fashionable gathering place at noon. Pranksters disrupted the service on the trolley at times by placing railroad signal "torpedoes" on the track. When the tram hit the small explosive charge, pandemonium prevailed, scaring the mule, the driver, and passengers. The People's Railroad Company appeared in 1887 and other lines were added. Electric trolleys replaced the placid mules in 1900. By 1920, 18 miles of track operated by Stone and Weber served the city until 1925, when the Kentucky Utilities Company took over and replaced the 13 trams with buses the next year. The rails were taken up during World War II for scrap iron desperately needed for the war effort.

Paducah became a third-class city in 1856. A two-story brick building at 124 North Fourth Street served as city hall until replaced in 1882 by this structure designed by George C. Davis. Mayor Charles Reed replaced the old city hall with a two-story brick building that had a third story added in 1909. Shown here is city hall just before its destruction in 1965, when city hall was moved to 300 Washington Street.

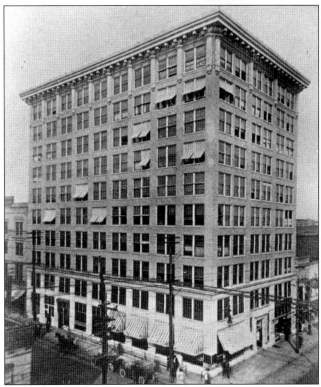

City National Bank was the tallest structure in western Kentucky when completed in 1910. Though surpassed now by the Jackson House Apartments, the structure still dominates the downtown area. The clock on this building became the meeting point in town for many people from communities around Paducah. The original City National failed in 1931 and Citizens Savings took over. Recently, expansion and change in ownership has transformed the facility.

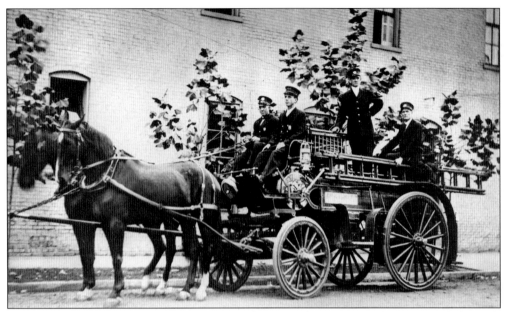

The Paducah Fire Department underwent a dramatic change at the beginning of the 20th century. Fire service became professional in 1882, but transportation still depended on animals; the shift from horsepower to internal-combustion engines started in 1912 and became completely motorized by 1916. Dogs were needed with horses to quiet them in the stalls; they remained as mascots. "Cleaning up the station" also took on a different meaning.

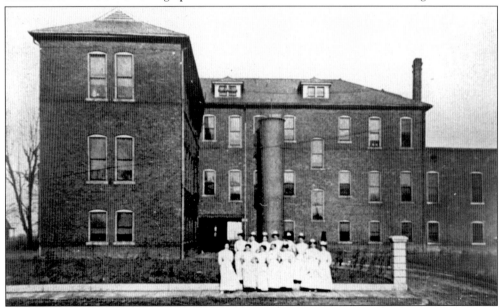

Riverside Hospital, shown here, was funded by the city; it opened in 1905 and quickly became a landmark to people in the region of Kentucky near Paducah. The Illinois Central Railroad also built a private hospital near their shops and roundhouse. The first building, a frame structure, burned and was replaced by the structure still standing on Broadway and Fifteenth Street. Recently, Paducah has evolved into a major regional medical center with state-of-the-art facilities.

"Angles" was originally the home of attorney Q.Q. Quigley. The name derived from the unusual configuration of the lots that were joined to form the site. Located originally on the western edge of the city, it became the home of Alben Barkley, Paducah's favorite son and the vice president of the United States under Harry Truman in 1948. Barkley "created' the present office of Vice President.

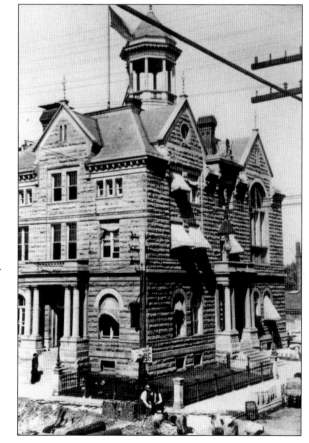

The federal courthouse at the corner of Fifth and Broadway housed the statue of Chief Paduke until after the 1937 flood. When this structure was razed to make way for a new post office, now the federal courthouse, stone from the site went to the south side of Paducah for Trinity Methodist Church. Unlike other churches west of the Tennessee River, Trinity was with the Louisville Conference.

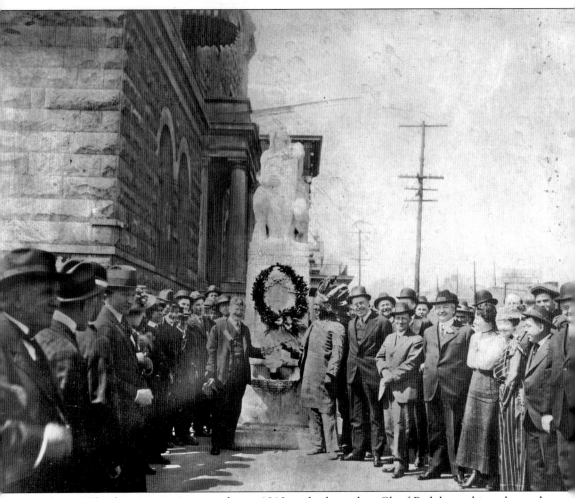

James Wheeler appears, center right, in 1913 as the legendary Chief Paduke and is welcomed by Mayor Thomas N. Hazelip Jr. at the dedication of Lorado Taft's statue. The Daughters of the American Revolution commissioned the project in 1909 and it was known in Taft's studio as "the Paducah Indian," not "Chief Paduke." Kenneth M. Bradley, president of the Bush Conservatory of Music in Chicago, made this known to Paducah in 1916. Immediate uproar led to a newspaper war involving Chicago, Paducah, Louisville, and others as far distant as New York City. Paducah refused to give up its legend that said William Clark came to meet his ancient friend in 1819 only to visit his grave. In fact, William Clark never mentioned this mythical figure. He did tell his son in 1827 he would name the city for the Padouca tribe that was destroyed by contact with Europeans.

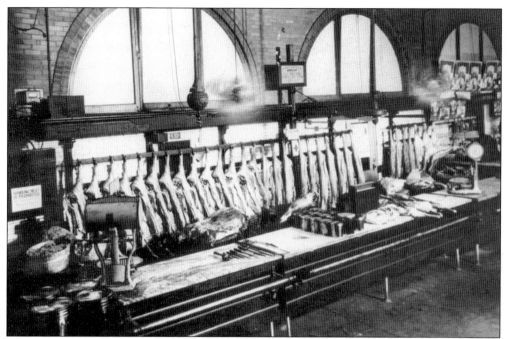

The city market provided Paducahans with meat and produce downtown until 1960. After 55 years, the very wood emitted a distinctive smell of salt and smoked meat and retained a distinctive feel in this section devoted to fresh meat. The Challenor family not only sold meat but processed pork and other meats at their slaughterhouse nearby. At the time, offal from the processing went directly into the Ohio River.

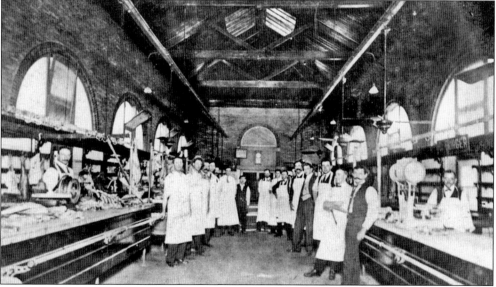

Stalls in the city market were rented yearly, and certain sites were highly prized. Originally, the city kept tight controls on location. "Foreselling" before official hours was punishable by a fine of $20 and trial by jury in the 1830s and 1840s. The Market Master was a city official highly regarded as necessary to protect the city monopoly on trade. Market fees were a valued asset to the young village of Paducah.

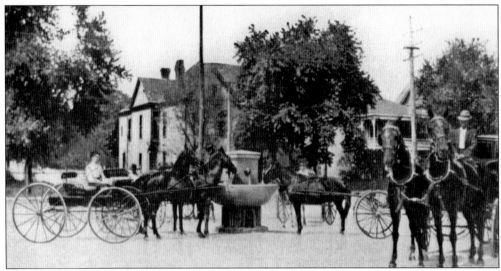

Concern for the well-being of animals suffering during the summer heat in urban areas caused a national philanthropic organization to donate funds for multi-use drinking fountains in Paducah and elsewhere. Herman Lee Ensign of Darby, Connecticut, founder of the National Humane Alliance, paid to erect a marble fountain to slake the thirst of horses, dogs, and other animals in the middle of Broadway at Tenth Street in 1907.

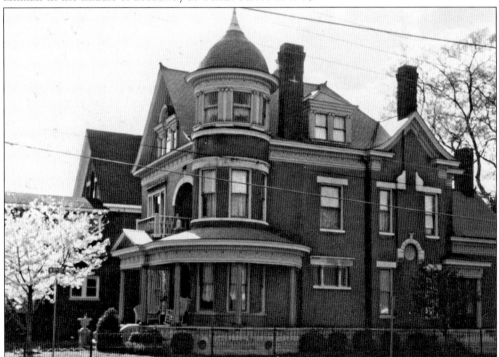

Frank Fisher, postmaster and leader of the local Republican Party, built this grand two-story house at 901 Jefferson Street about 1900. Fisher's father, John G., came to Paducah from Würtemberg, Germany, in 1838 and was elected mayor for 1863–1866 and 1875–1877. John operated the Eureka Brewery on Paducah's south side. The younger Fisher founded the *Evening Sun*, a daily newspaper, in 1896.

32

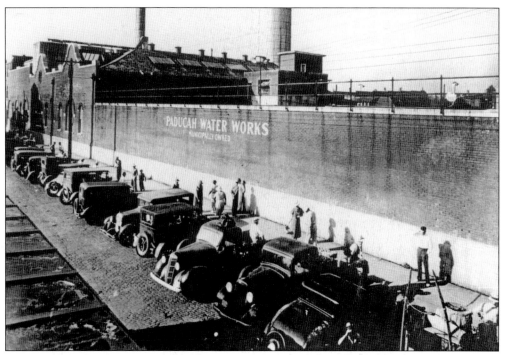

After 1886, Paducah's municipal public waterworks provided residents with purified water from a treatment plant occupying the entire city block at First and Kentucky. Fire protection also improved with the new double-sided fireplugs. Previously, the city dug a series of fire cisterns at strategic locations near downtown for fire emergencies. Originally, a 175-foot standpipe 22 feet in diameter served. As the population moved west, so did the main city reservoir.

George Steinhauer's family played a prominent role in Paducah early in the 20th century. George, shown here in his office seated left, was secretary/treasurer of the Independent Ice and Coal Company, and his brother Fred was manager. The family donated a treasure-trove of photographs that are now housed in Special Collections at the McCracken County Public Library. The 1913 flood record is most valuable.

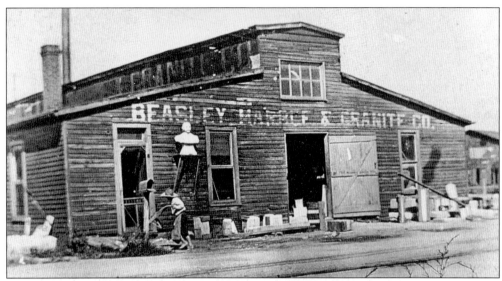

Beasley Marble and Granite Company at 1101 South Thirteenth Street moved to Paducah in 1907 from Tennessee and is one of the oldest firms operating in Western Kentucky. The firm was founded by Joseph W. Beasley and continued under Walter Lipscomb "Dub" Beasley Jr. until his retirement in 1998. The marble bust outside the door is that of the founder, carved by Walter Sr. The present façade dates from 1933.

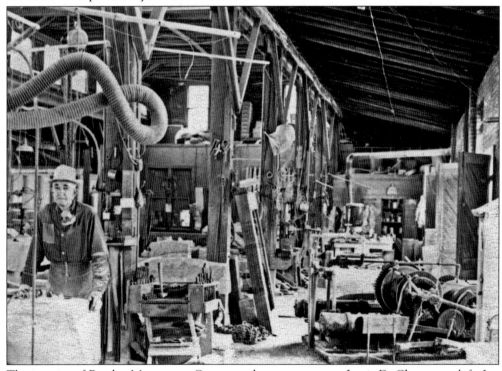

The interior of Beasley Monument Company shows stonecutter Louis D. Champy at left. Joe Beasley is barely visible in the office window. Champy served 55 years. Employees initially were all male; this changed in the 1950s. Ingenuity and basic mechanical skill were prized, as the size of many monuments, such as that of noted actor and author Irwin S. Cobb, proved challenging.

Immigrants Herman and Jacob opened Wallerstein's Men's Clothing store in the Richmond House in 1868. The firm moved to various locations until finally settling at this site at Third and Broadway in 1888. Later the firm expanded and changed its appearance. The side of the building seen by traffic moving toward the river boasts that it was the clothier of famous Paducahans. Today Wallerstein's is an antique store.

The Nashville, Chattanooga, and St. Louis Railroad built the NC&St.L freight station in Paducah in 1925 at 300 South Third Street. The station also served as the southern terminus of the Chicago, Burlington, and Quincy Line. This facility served the wholesale suppliers of fruits, vegetables, and produce that were offloaded onto trucks and distributed to merchants located in several nearby states. Later the building served the Johnston Brokerage Company.

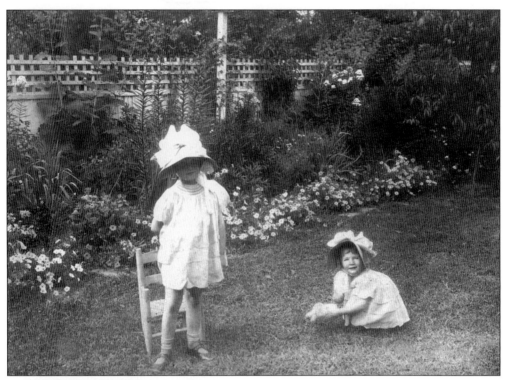

The current generation has lost one of the delights of childhood—Easter hats. In 1926, style and decorum demanded that proper ladies in Paducah had to wear hats to church and funerals. Warm weather not only allowed children to play outdoors, but it allowed them to imitate their mothers by "dressing up." These two charming young girls delight in their fantasy in their backyard.

Storefronts on Second Street now display their original cast-iron fronts, most a product of various Paducah firms. Changing concepts of style led owners to "keep up with the times" by hiding these wonderful castings. After the 1950s, interest grew in accurate restoration of the entire area to its pristine presentation. The brick street reemerged from its asphalt cocoon to remind visitors of the history of the town.

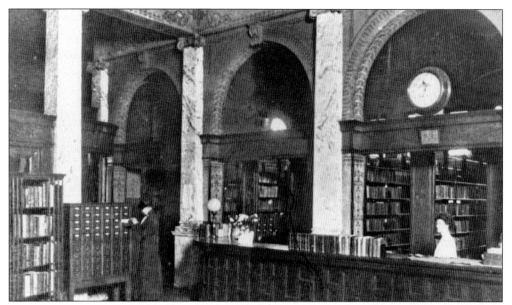

Andrew Carnegie funded the erection of a public library at Broadway and Ninth Streets in 1904. Isaac Bernstein donated funds, enlarging the holdings and their display. Harriet Boswell served as librarian from 1924 until 1959 and ran a tight ship. African-Americans were only allowed in the basement area at first. After the creation of Paducah Junior College in 1932, its library was on the second floor. Fire devastated the building in 1969.

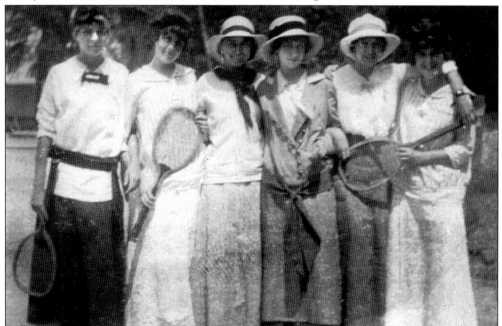

Throughout the latter years of the 19th century and the first two decades of the 20th century, women gradually gained legal rights. Along with this changed status came opportunities to participate in education, politics, and social activities previously reserved for men. Often this required daring changes in attitudes as well as in attire, such as that worn in this tennis match. The "bloomer" was the uniform of the new woman.

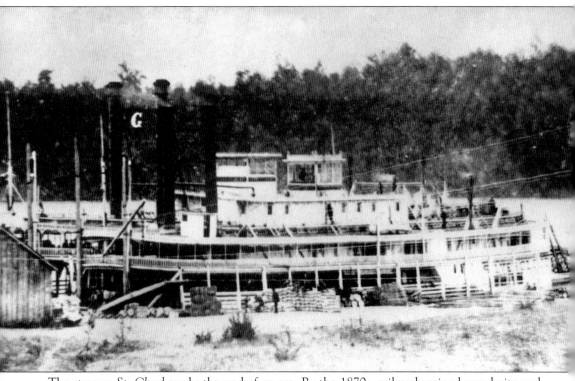

The steamer *St. Cloud* marks the end of an era. By the 1870s, railroads gained popularity and siphoned off passengers and cargo from the paddle wheelers that plied the inland waterways. Advances in dam construction improved navigation and flood control so that the river industry has since returned to significance, and towboats with propellers at the rear move vast quantities of cargo. Paducah is a hub of this new transportation system.

Fountain Avenue Methodist Church was built in 1908. The city trolley line ended beside the church on the western limit of the city, but the city was growing rapidly at the time. In 1922 the church hosted a meeting of women. Three years later a Willing Workers class began for women who were mainly young mothers with families. This group became the core of the congregation.

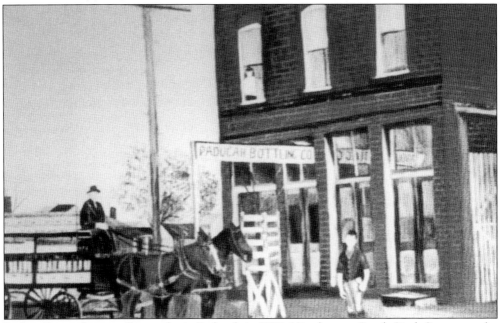

Luther Carson began selling sodas in Paducah in 1903. His plant on South Sixth Street was the nation's seventh bottler of Coca-Cola. The 1937 flood damaged the site severely, forcing a move to Broadway and LaBelle in the west end of the city, just yards beyond the high-water mark in 1937. The lobby of the plant designed by S. Lester Daly was a showplace complete with marble fountain dispensing Coca-Cola.

Many Paducah businessmen chose to live over their establishments prior to 1900, as did the Rogers family. The advent of the trolley allowed people to live away from the center and still get to work easily, and suburbia became a familiar condition. In Paducah, whites moved into the city early in the morning while maids and yardmen went in the opposite direction. The flow reversed in the afternoon. Note reference books on the shelf.

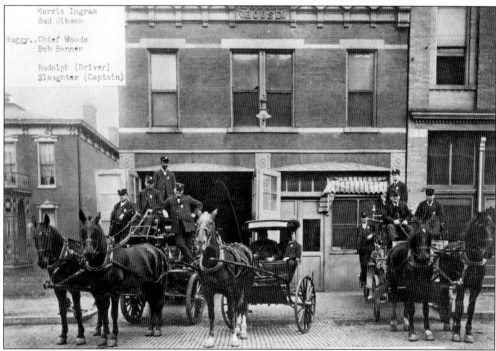

The fire department had four hooks to pull down burning walls and four ladders in 1835. Circus owner Dan Rice was helped by Paducahans early in his career and donated the city's first steam engine pulled by horses as a gesture of remembrance. All that changed early in the 20th century. In 1912, the fire chief got an automobile. By 1916, the entire fire department was motorized.

Three
CHURCHES

In 1833, Paducahans formed their first church, which evolved into Broadway United Methodist. Kentucky Methodists had declined to supply clergy to serve in the newly opened Jackson Purchase region of Kentucky and Tennessee the Depression of 1819. Tennesseans took up this mission. As a result, up to 1968, except for Trinity Methodist in Paducah, Methodist clergy in the Purchase came from the Memphis rather than the Louisville Conference. A variety of congregations located in Paducah: Catholic, Methodist, AME, Baptist, Episcopalian, Lutheran (speaking German until 1918), Reformed Jewish, Church of Christ, etc. Being a river town, Paducah was reputed to be a good place to party. Up to 1913, liquor stores outnumbered churches. Still, religion is vital to Paducah.

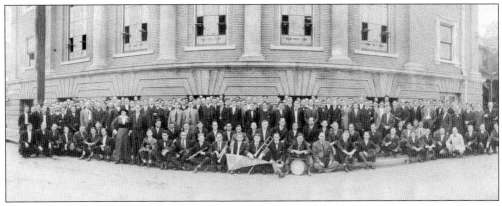

The Paducah First Baptist Church traditionally has one of the largest congregations in town, demonstrated by this 1915 men's class. The congregation formed in 1840, led by Brother James P. Edwards. The original building served as a hospital in the Civil War and was replaced at Fifth and Jefferson Streets by this brick building. Membership was more than 1,000 by 1927. Note the lone woman.

Fountain Avenue Methodist began as a mission outreach of Broadway Church in Davett's former saloon. In 1892, the group's growth merited a separate minister, W.E. Sewell. A building on Trimble, now Park Avenue, served from 1893 until 1908 when the congregation moved to the present location on Monroe and Fountain Avenue, now Seventeenth Street. At the time, the trolley line ended beside the church at the western limit of the city.

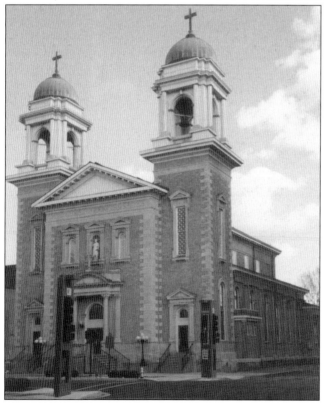

St. Francis de Sales is one of the many Roman Catholic churches in western Kentucky founded by Fr. Elisha Durbin from Uniontown, Kentucky. The original structure was built on Broadway at Sixth Street in 1848; the present structure dates from 1889 and displays both baroque and renaissance features. A major renovation began in 1949 when Leo Mirabile, 73, restored his original mural. Renovations are ongoing. A new parish hall was dedicated January 23, 2004.

In 1848 Grace Episcopal Church occupied a pre-fabricated frame structure on the west side of South Second Street. The family of Lloyd Tilghman worshiped there until 1861. Like others, the building became a hospital after the Battle of Shiloh. In 1873 construction began on plans by architect Henry M. Congden of New York. Construction ended in 1883. The bell-tower has a distinctive slate roof with the Star of David.

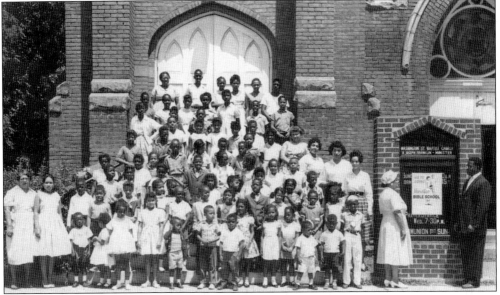

A white minister from First Baptist also served Washington Street Baptist Church in 1855, meeting in a log cabin on the present site. In 1858 an African-American pastor arrived; by then, enslaved members of Pleasant Green Church in Lexington had purchased George Dupee's freedom. Later, a handsome brick church, built in 1893, was replaced in 1968 with the present building, and an educational hall complex was added in 1988.

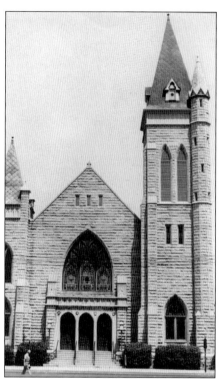

Organized in 1841, Broadway United Methodist Church is the oldest congregation in the city. In 1875, a larger structure arose on Broadway and Seventh Streets that lasted until 1896 when the church moved to its present site and to a new stone building designed by D.A. McKinnon of Paducah. Fire seriously damaged the structure in 1929 but it was rebuilt. Broadway United Methodist Church purchased Paducah Junior College's facilities next door in 1964.

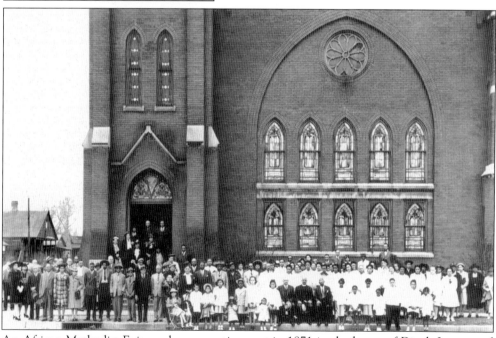

An African Methodist Episcopal congregation met in 1871 in the house of Dinah Jarrett and named their chapel in honor of Moses Burks, a slave pastor. The present structure dates from 1911 under the leadership of P.A. Nichols. This handsome building is shaped like a cross with a soaring bell tower entrance flanked by two minor towers with Gothic-revival–style lancet openings and salient buttresses.

Presbyterians, like Methodists, met in homes during 1842 but organized formally in 1843 in the county courthouse. The congregation had a brick building erected in 1845 at Third and Kentucky Avenue that continued to serve until 1888. The membership moved to their new building in 1889 on Seventh and Jefferson Streets. Fire ravaged the structure in 1932 and the present Oxford Gothic structure replaced it.

The Goebel Avenue Church of Christ organized under an oak tree in 1908 and moved into a frame structure that year. Continued growth required the church to change its name to the Broadway Church of Christ when it moved to a brick building completed in 1923 at Broadway and Nineteenth Streets. By 1959 even larger quarters were needed, and a move to 2855 Broadway allowed further service to Paducah.

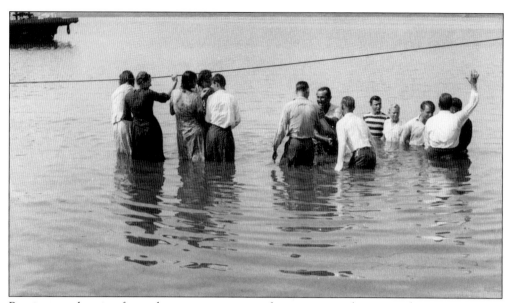

Baptism at the riverfront downtown was a tradition among the many denominations in Paducah. Both African-American and white congregations gathered and celebrated the rite of passage for members—at different times and at different locations, as the flocks were segregated at the time this photograph was made. Funeral homes, churches, and schools were the most rigidly segregated social institutions throughout Kentucky and the South until after World War II.

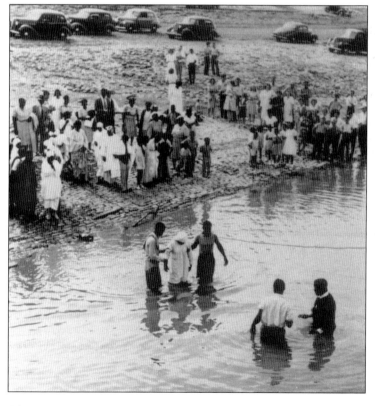

Racial segregation became the standard after *Plessy v. Ferguson* in 1896 and lasted until after World War II. No area was so segregated as religion. Baptism might be by the same denomination and in the same water, but participants were rigidly parted in time and place. African-American women were not allowed to try on hats and underclothing in stores. Drinking fountains had to have duplicate facilities for whites and African-Americans.

Four

STAGNATION
1913–1950

Growth in Paducah did not slow even after the 1913 flood; however, the 1937 flood that forced 20,000 people to flee Paducah and inflicted millions of dollars worth of damage to the community was another matter. Because of the flood coupled with the Great Depression, Paducah entered a long period of economic stagnation. It was not until the floodwall was finished in 1946 that recovery began and bloomed with the arrival of the "atomic plant" in 1950.

Charles Wheeler poses with his sisters. Wheeler served the First Congressional District of Kentucky from 1897 until 1903. On leaving office, Wheeler gave this carefully considered advice to aspiring politicians: "I would not advise anybody to enter politics unless he is very poor or very rich. If poor, he had not much to lose. . . . If he is rich he has a better chance of enjoying his experience."

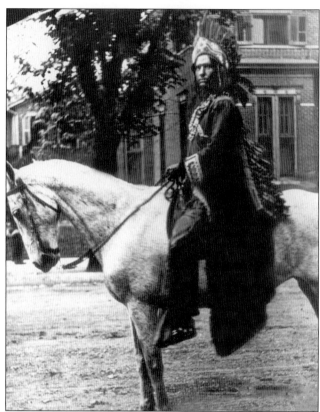

"Homecoming week, May 19 to May 24" was celebrated in 1913, complete with the arrival of James Wheeler as the legendary Chief Paduke. The city had weathered the recent flood, cleaned up its image by ridding the city of over 300 prostitutes, and looked forward to a bright future. Mayor Thomas N. Hazelip gave Paduke a welcome before a joyful crowd of thousands near the post office at Fifth and Broadway.

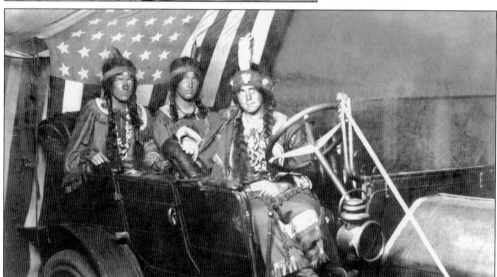

Accompanying the legendary Chief Paduke in 1913 were, from left to right, "Princess" Adine Corbett, Ruth Hinkle, and Bertha Ferguson as maids of honor. Wheeler arrived at the foot of Broadway, descended from steamer G.W. *Robertson*, mounted his horse, and rode to Fifth and Broadway. Later, Wheeler married Miss Ferguson. Wheeler promoted equestrian skills, especially the art of dressage. A love of horses and the pleasure of riding them captivated Wheeler into his 90s.

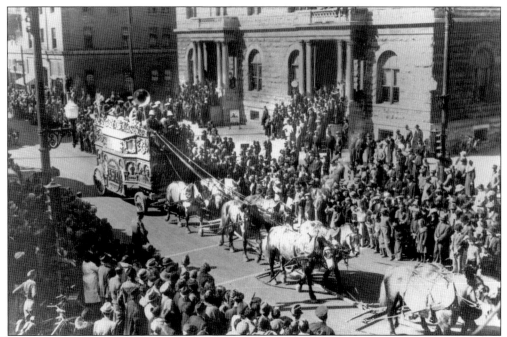

In 1916, war loomed in Europe, and American troops were busy chasing Francisco "Pancho" Villa in Mexico to no avail. Villa had killed Americans at Santa Ysabel and had raided into the United States at Columbus, New Mexico. These events were noted in Paducah but the visit of a circus took priority. Barnum and Bailey opened with a grand parade that brought both beautiful and bizarre attractions to the amazed city.

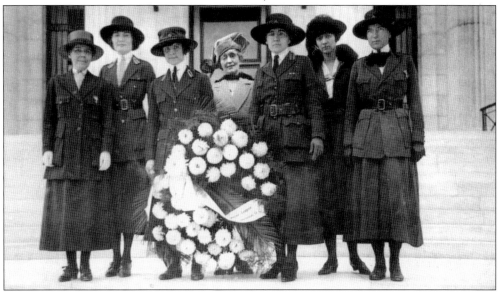

Women made a significant contribution to the effort to end "the war to end all wars" in 1917–1918. One avenue for such participation was with the Red Cross. Bandages had to be rolled and sent to the front in France. A 1918 drive for $25,000 collected $40,000. The city was also most generous in the Liberty Bond drives. In one, a float with electric lights came from St. Louis.

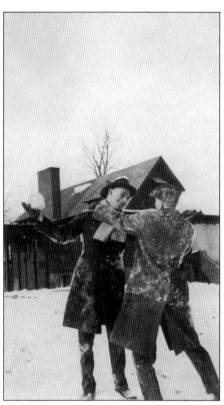

The winter of 1917–1918 produced blizzards that piled heaps of snow on Paducah and the surrounding area. Digging paths downtown created shoulder-high snow "trenches" from store to store. Approximately two feet of snow proved to be an irresistible lure for those young at heart to frolic. Fred Neuman reported that this was "the heaviest snowfall since 1864." The Tennessee River froze to a depth of eight inches on January 14.

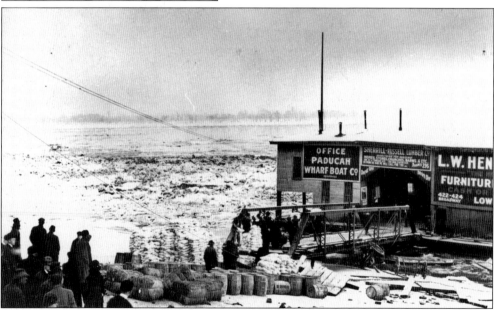

The cold winter of 1917-1918 also played havoc with shipping. The narrow passage between Owen Island and the bank of the Tennessee River, called the "chute," captured several steamers and barges in thick ice. Pictured is the city wharf boat at the mouth of the chute just before the thaw began on January 18 that sank many vessels and damaged others with claims in excess of $1 million.

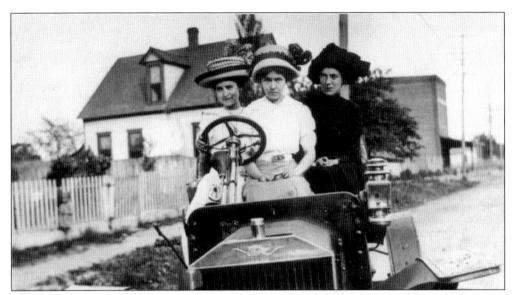

Three women in this Ford avidly anticipate the open road. Note that Henry Ford had not yet decided if the steering column would be on the left or the right. He preferred the English example at this time. Also note that the car does not have a left-hand door. Driving was for the hardy. Set the spark and throttle levers like a clock at ten and then crank.

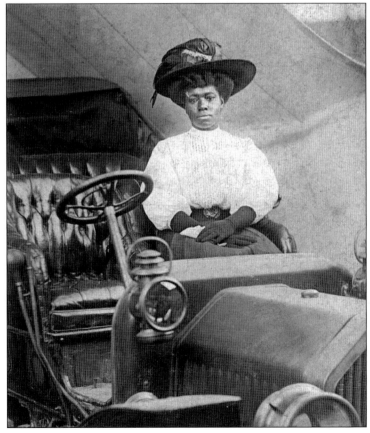

Automobiles came to Paducah in 1901 when an Oldsmobile arrived for Dr. J.D. Robertson. *The Evening Sun* reported the vehicle was the "first of its kind owned by a Paducah man." A shipment of Fords arrived on June 14, 1904. By 1919, automobiles still held an aura of affluence and were used by a local photographer as a prop. Note the attire of the young African-American woman complete with driving gloves.

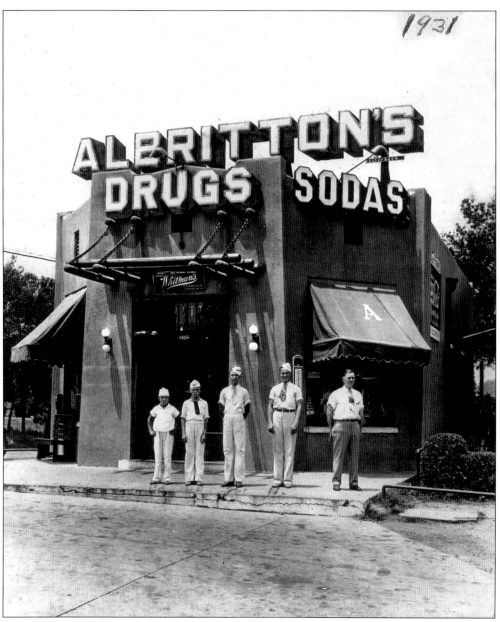

Albritton's Drugs, shown here in 1931, was the point of gathering for young people in Paducah from the 1930s to the 1980s. Needless to say this business was strictly a family enterprise; the Albrittons are, from left to right, Charles E. Albritton, Lawrence E. Albritton, Walter E. Albritton Jr., John Harper Albritton, and Walter E. Albritton; Marilyn R. Albritton Simpson is not shown. The store was one of the first "drive-in" establishments in town. Located at the demarcation between the flood-prone zone toward the river and the emerging affluent residential west end, the store was the "place to be" for Paducahans who fondly remember ordering delicious "Chip Chocolate" ice cream and the nickel "hot ham" (fried bologna) sandwiches. For a while, the Albritton family lived in a house behind the store. Later this was moved to Jefferson Street. The city tram ended behind the store on Jefferson. A brief walk across LaBelle and one always felt welcomed at Albritton's.

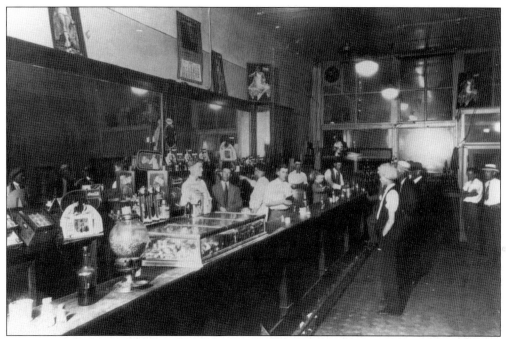

After making the world "safe for democracy" in 1918, reformers went further. They ended the manufacture and sale of alcoholic beverages and they gave women the right to vote. In Paducah a favorite watering spot met the "Brave New World" with grim determination. They installed a soda fountain and pool tables, and the patrons grew younger. The vote for women proved successful; Prohibition was less well received. The law was often ignored.

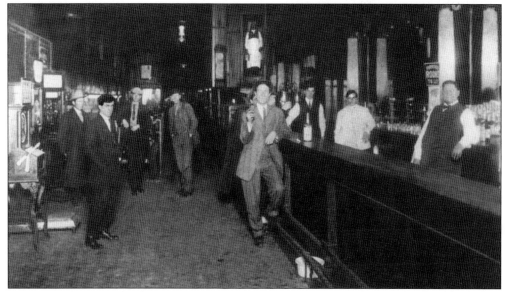

Henry Steinhauer and Tyler White purchased S.B. Gott's saloon at 119 North Fourth Street in 1917. Prohibition brought "near beer" in 1919 but never ended the yen for good brew in Paducah. In 1933, lager returned; however, Heinie and Tyler's served only men. Until 1969, women at Citizens Bank wishing for the famous oyster sandwiches at noon had to send Bane Barton, the bank's porter, to the "take-out" window.

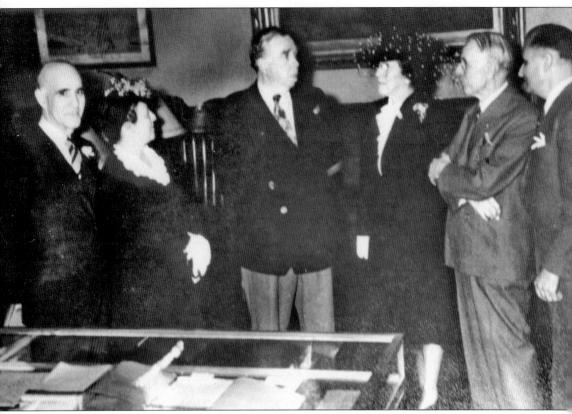

Irvin S. Cobb left Paducah as a young man but kept a fond regard for his birthplace. Cobb went to work at 16 on *The Paducah Daily News* and became its night editor three years later, only to get into legal trouble because of his lack of experience. Cobb went to Louisville with the *Evening Post* and gained recognition as an excellent reporter. In 1901 Cobb returned to Paducah as editor of the *Democrat* until 1904, when he moved to the East Coast and his career took off. He became a famous war correspondent in World War I, a noted and respected reporter, a humorist with a flair for the curious turn of a word, an author whose use of dialect rivaled that of Mark Twain, a lecturer, a movie actor in *Steamboat Around the Bend* with Will Rogers, and Paducah's first "Duke." Cobb's autobiography, *Exit Laughing* (1941) is a national treasure. In 1928, a hotel was named in Cobb's honor.

After 1929, the Irvin Cobb Hotel, named for favorite son Irvin S. Cobb, quickly became the center of social life in Paducah until a fire damaged it in 1972, leading to its reconstruction as apartments for the elderly. In its heyday, debutantes and dandies flocked to the ballroom for festive evenings while various civic clubs met regularly in its dining room. In the 1940s an elegant maitre d'hotel supervised this staff of young men in proper decorum.

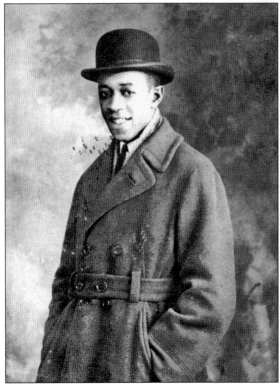

Unlike Louisville and other cities, Paducah did not have one principal segregated area for its African-American citizens in the mid-20th century; still, each race had its distinctive culture that flourished in its principal areas. Movies had separate entrances. There were no toilet accommodations just for African Americans downtown. In each culture there was a marked division between youth and mature adults, especially in clothing and behavior.

55

Cobb returned to Paducah for the celebration of his 50th birthday on June 23, 1926. While in town he was wined and dined at the Women's Club auditorium and honored at the Carnegie library. Among his many causes was opposition to the Klu Klux Klan. Cobb even returned to Paducah in 1923 and edited one issue of the local paper that helped prevent the racist organization from meeting in the city.

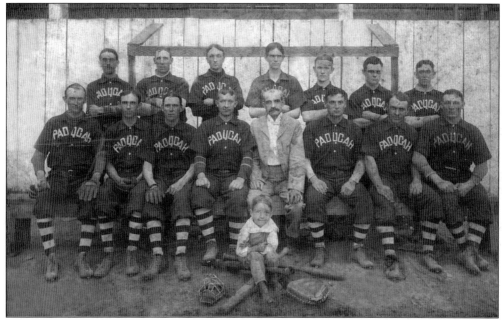

Wallace Park, at Thirty-Second and Broadway, hosted Paducah's baseball teams between 1904 and 1908. After 1927 they played at Hook's field, at Eighth and Terrell Streets. The Chiefs, resurrected in 1947, played at Brooks Field. The franchise was part of the Milwaukee Braves system in 1949 as part of the Mississippi-Ohio Valley League and changed to the Kitty League in 1951 with relations to the St. Louis Cardinals. Television decreased interest in local sports.

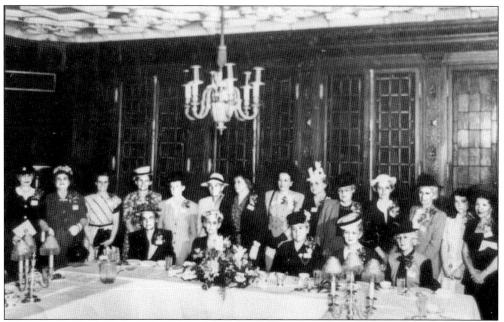

Social functions frequently involve banquets honoring various citizens and causes. The Illinois Central Ladies auxiliary met at the Irvin Cobb Hotel regularly. No one would dare be seen without proper accoutrements such as the hat then in vogue and the proper dress for the season at hand.

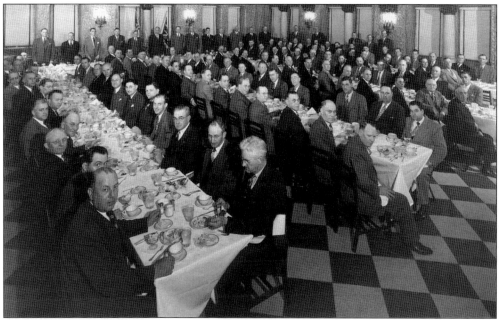

The administrative offices of the Kentucky Division of the Illinois Central Railroad were located at 1500 Kentucky Avenue. Frequently visitors from Chicago required a banquet at the Cobb. Women were few, usually telephone operators or clerical personnel. Division office personnel were still predominantly white males as late as the 1950s. Each desk sported its own spittoon that was emptied each morning by one of the two African-American porters.

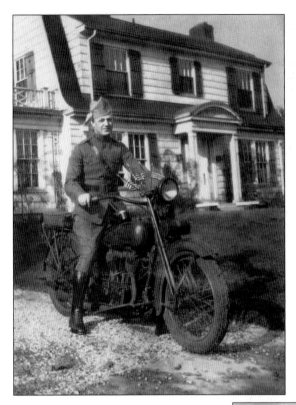

Gus Hank Jr. was a captain during World War I. In France he rode Harley-Davidson motorcycles, serving as a special-dispatch rider. On occasion he bragged that he noticed a German airplane diving at him with the intent of strafing. Gus flattened himself on the frame and wrenched the throttle handle as far as it went, and he got away. The bike came home with Hank—the first in Paducah.

Mary Wheeler did while others talked. She went to France with the Red Cross in 1918 to entertain the troops. Later, she collected folk songs in Appalachia and later, Ohio riverboat work songs, which she published in *Steamboatin' Days: Folk Songs of the River Packet Era* in 1944. Miss Mary earned both bachelor's and master's degrees at Cincinnati Conservatory of Music and taught at various places including Paducah Junior College.

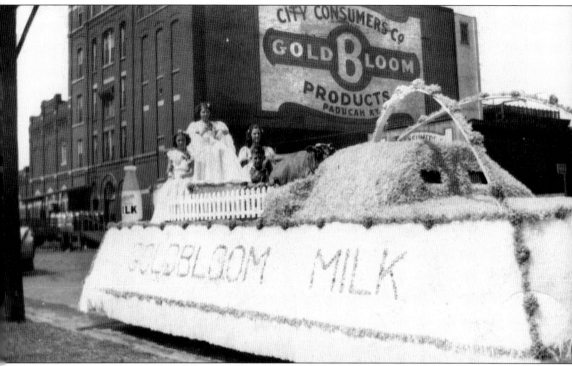

In 1913, E.J. Paxton Sr., editor of the local newspaper; W.F. Bradshaw, a banker; Con Craig, secretary of the Paducah Board of Trade; and W.E. Cochran and H.C. Rhodes, merchants, formed the McCracken County Strawberry Growers Association. Beginning in 1914 when half a carload was shipped out, strawberries played a major role in the economy of Paducah until the early 1950s. By 1935, the market contained nine counties and 5,000 members planting over 4,000 acres. That peak year 830 carloads of berries were shipped by rail from Paducah. Growers got $5.56 a crate prior to 1930. Starting in 1937 a festival celebrated the season, complete with a Strawberry Queen, marching bands, and several days of activities. World War II put a halt to the occasion for a time. It resumed in 1945 and lasted until 1948. This float by Goldbloom Dairy was typical of the entries. Anna Lou Shaffer French, Verna Jean Subblefield, an unidentified girl and boy, and a Jersey cow constituted the crew for the float.

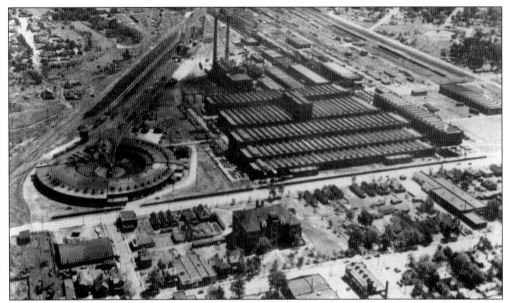

The railroad shops of the Illinois Central were among the largest in the world when construction began in 1925. The project moved Coleman Hill 16 miles away in McCracken County to use for fill. Completed in 1927, the facility built 20 of the 2,600 Mountain class 4–8–2 steam locomotives, identified by their extended capacity tender that allowed them to make the run from Fulton to Woodstock, just outside Memphis, without taking water.

Originally Goldbloom Dairy used horses to deliver milk. These animals soon knew the routes better than some drivers. One had to persuade the horse otherwise when a patron changed their usual order. No matter how faithful, the horse could not compete with the advent of the gasoline-powered engine. Now exhaust changed Paducah's streets—soon some noticed the reduced number of birds downtown.

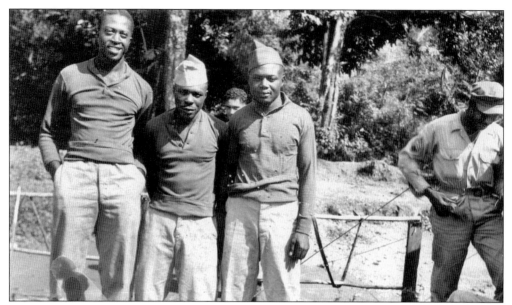

In 1945, segregation denominated the composition of the armed forces. African-American soldiers often were assigned to menial tasks rather than integrated combat units. One example of this stereotyping was the "Red Ball Express" supply outfit that managed to keep up with the 3rd Army of George Patton in the race to the Rhine. President Harry S. Truman integrated the military by executive order in 1948.

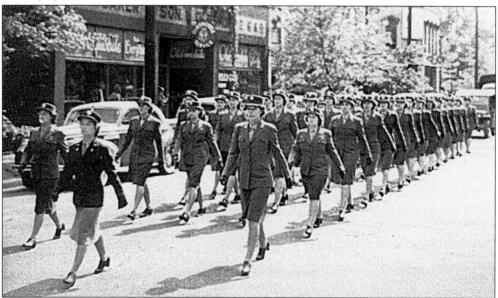

Women made a significant contribution in World War II. Over 300,000 served in the army as nurses and the WAACs (Women's Auxiliary Army Corps) that later became the WACs (Women's Army Corp). The navy had its WAVEs (Women Accepted for Volunteer Emergency Services); there were women marines. Women enlisted in the SPARs (U.S. Coast Guard Women's Reserves) and WASPs (Women Airforce Service Pilots). Twenty-five percent served overseas. In 1939 only 36 women worked in shipyards; in 1945 the number reached 200,000. "Rosie the Riveter" became a role model for women.

The traditional celebration of November 11 as the end of World War I took on greater meaning in 1945 as World War II finally came to an end in September with the surrender of the Japanese. A grateful people turned out in record numbers to commemorate the sacrifice of so many. Throughout the crowd were recent returnees with the "ruptured duck" badge signifying they were recently released from active duty.

The Carnegie Library in Paducah opened opportunities to explore the world through reading to the youth of Paducah and McCracken County. Special incentives, such as the event portrayed here, whetted the appetites of children to delve deeper into the rich heritage of the previous generations. Carnegie firmly believed that the secret to improving the lives of the workers in America was to make educational opportunities such as libraries available.

Five

FLOODS

Paducah became the county seat in 1831 after Wilmington proved unsatisfactory due to flooding. A two-story brick courthouse rose on the lot at what is now Kentucky and Second. By 1857, the need for a larger structure was apparent. Some opposed moving the seat of government "so far out" to the site between Sixth and Seventh Streets and Washington and Clark. This building, a Works Progress Administration (WPA) project, was completed between 1941 and 1943. Floods were expected along rivers. Paducah, like any river city, accepted the danger of its proximity to the Ohio and Tennessee Rivers as a part of life. Rises were noted in 1815, 1822, 1828, 1832, 1867, 1883, 1884, and 1897. A pattern seemed to be emerging but went unnoted; however, the perception of Paducah as being "high and dry" came into question in 1913 and changed completely in 1937.

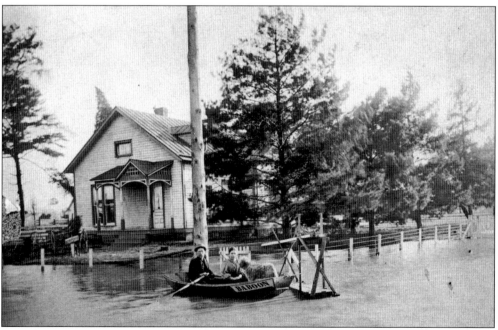

The site at Paducah appeared safe from serious damage until 1913 and 1937. In 1913 water got into the downtown area with little damage; many thought it would be worse. The fact that the Mississippi flooded in 1913 made the prospect for the Ohio Valley more than dismal. However, by the time the river crested at 54.3 feet on April 7 at Paducah, the situation on the Mississippi had eased.

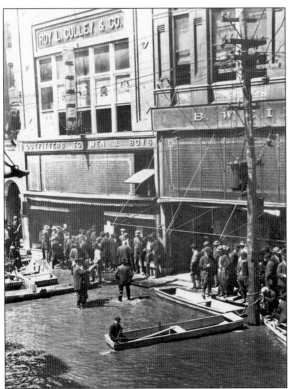

City papers on April 7 proudly proclaimed, "Paducahans didn't let this flood bother them any more than the Paducahans of 1884 were bothered by that rampage." The crest of 54.3 feet was 10 percent higher than in 1884. Actually there were elements of fun for those with boots and hastily constructed "john boats" that kept the waters about two inches from the passengers. One hundred families had to be evacuated.

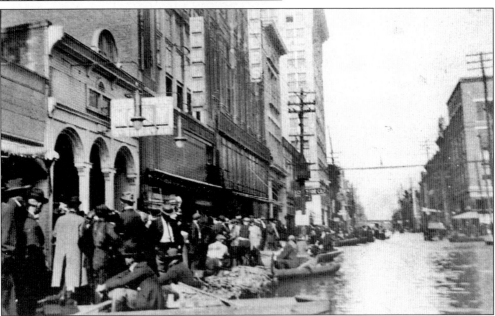

Boaters went joyriding down Broadway at the height of the flood in 1913. Water at Third and Broadway was only three feet deep; however, there was a strong crosscurrent at that intersection that could tip a clumsy craft. Most lacked a keel or other aids to stability. Automobiles inched along the streets and the trams had thrill-seekers handing on the sides while nearing the bustling market.

Prisoners were moved out of the jail in the basement of city hall. Mayor Thomas Needham Hazelip and his associates watched the flood descend the Ohio River. Louisville suffered in March and the river at Paducah was expected to rise two feet a day. The mayor proudly proclaimed that no outside aid was needed.

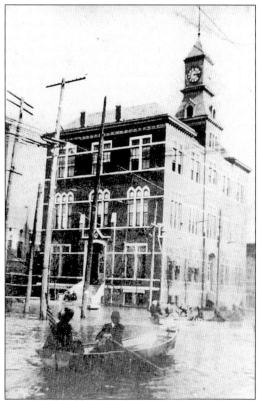

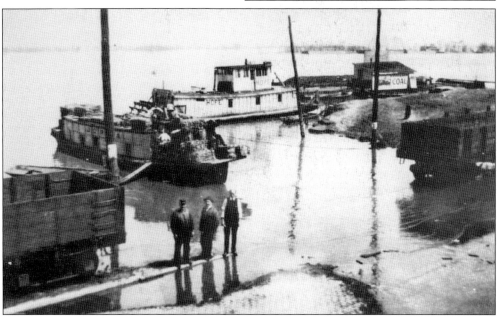

In 1913 parts of the city were flooded; for other parts, like this site along the front of Broadway and Kentucky, the rise was only a nuisance. The wharf boat was still accessible with boots at this stage. Water stranded a tram on the bridge at South Fourth and Tyler. Paducah paid scant attention to the flood, looking ahead to the homecoming celebration held that year.

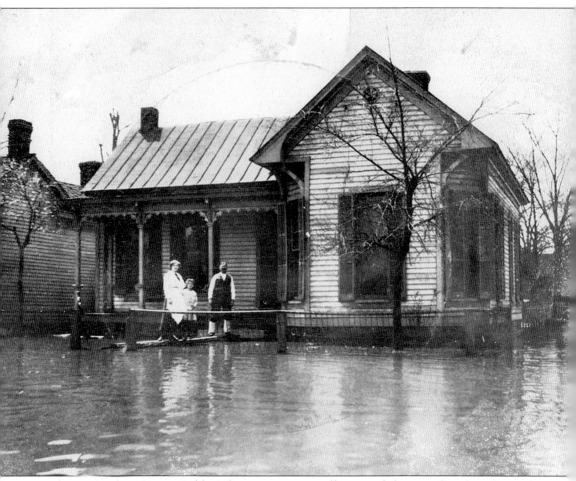

The McCracken County Public Library possesses a collection of photographs taken during the 1913 flood. Visions of frolic were recorded in the majority of the images. A trolley with water up to its footboard was crammed with sightseers. Gapers lined the streets downtown to marvel and scoff at the invading water. The few automobiles available were pressed into service to see if they could penetrate the invading tide. The general tone of the images is light-hearted while the event is ominous. Paducahans were blasé, accepting the event as a natural consequence of living on the banks of the two rivers. While higher than any previous flood, the rise was nothing that they could not overcome using their own resources. The city did not seek or get outside assistance. Attorney B.W. Cornelison and banker William F. Bradshaw Jr. organized relief efforts. One hundred families were evacuated, but their homes were not ruined. Six thousand dollars covered the damage from the flood and that was paid for out of local resources. Paducah braced for the upcoming homecoming celebration.

It seems that a giant puddle and wearing hip boots transform otherwise sober Paducah citizens into gleeful children, as this view of George, Fred, and Chris Steinhauer proves. South Fourth Street was one of the worst hit areas during the 1913 flood. The city took pride in the fact that they handled their damage without any outside assistance. This was not to be the case during the 1937 flood.

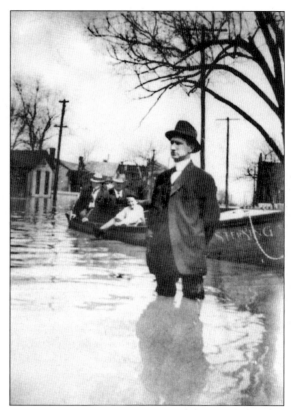

Not content just to watch George frolicking in the flood, the party of the Steinhauers and friends in 1913 proceeded further on South Fourth Street seeking adventure. The presence of a utility pole beset by the flood proved irresistible. Each tried to outdo the other for the camera. Fortunately no one fell into the water. Their daring did not eclipse that of the holder of the Kodak.

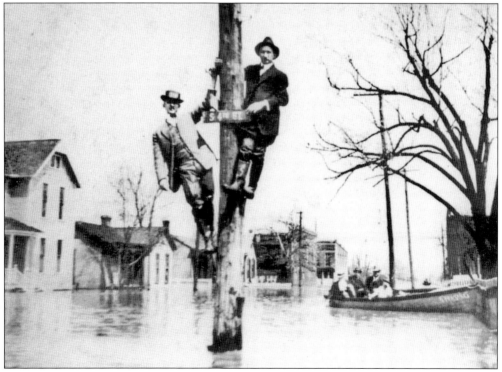

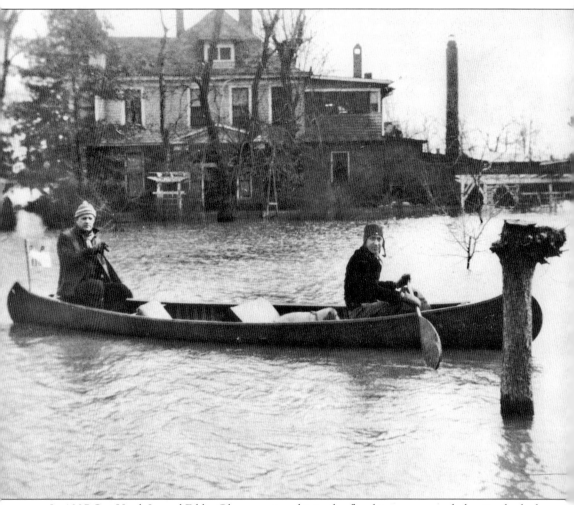

In 1937 Gus Hank Jr. and Eddie Glenn ventured into the flood in a canoe and, despite the lack of stability, found it necessary to share their transport with one less fortunate than themselves. Unlike the dog here, pets and animals suffered or died when they were unable to escape the rapidly rising waters. Many Paducahans tried to aid the marooned animals and would marvel about the lack of animosity among those poor creatures stranded. Cats and dogs co-existed on shed roofs on several occasions. One cat survived over a week inside a house with water up to the top of doors. When offered a bit of ham that had been left in the room, the cat ate both the ham and the paper enclosing it. The most famous stranded animal was a cow that survived on the second floor of a porch and was fed and milked daily. Still, various animal carcasses polluted the backwaters. Human corpses often appeared as well, popping up from fresh graves.

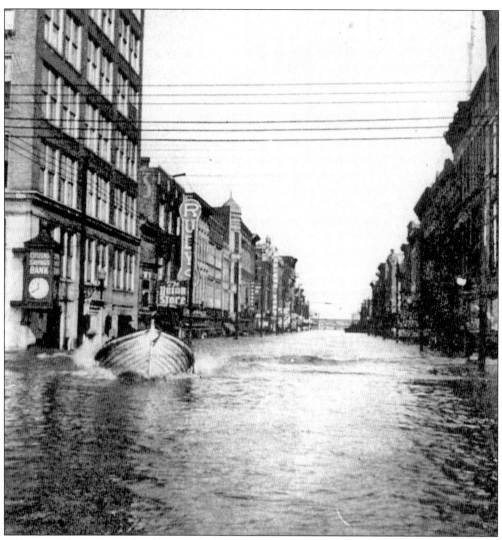

For many, this picture, made available by Sherry's Antiques, epitomizes the 1937 flood in Paducah, Kentucky. Citizens Bank, 333 Broadway, was the "hub" of the downtown shopping area. The clock was often used as the meeting place for those from out of town after shopping in the various stores in Paducah. During the flood it was also a noted meeting place. Note the turbulence in the water as the Coast Guard cutter passes the intersection of Third and Broadway. A viscous crosscurrent made this spot dangerous to passing craft, especially the poorly constructed "john boats." Noble Clark spent 46 years working for the bank, rising to vice president. After water forced the bank to close, Clark returned with a friend in a homemade skiff that lacked a rudder. At the cross street, the craft was literally thrust through the intersection and into the plate glass of a store. Shards fell like guillotines, forcing both to jump into the frigid water. Fortunately they found an upper room that still had coke heat and dried off.

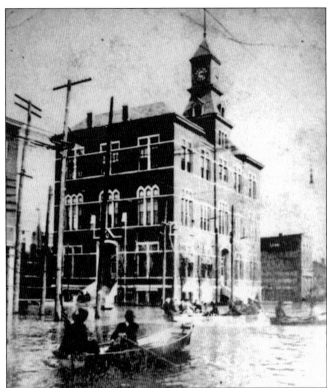

City Hall suffered more severely in 1937 than in 1913. Prisoners were moved to the west end and put in the cellar of Jack Keiler's house until they could be transported via the Illinois Central Railroad to Mayfield. Riverside Hospital and the hotels downtown had to be evacuated. A medical clinic was opened at Clark School in the west end. City governmental agencies also transferred operations to the Avondale area.

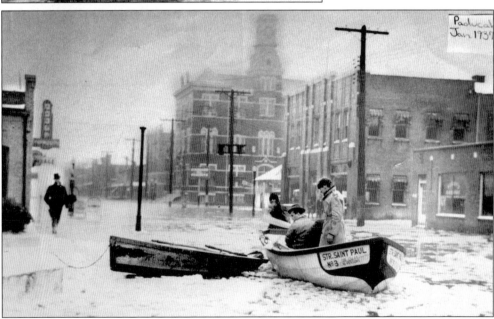

The steamboat *St. Paul* contributed a boat to help with rescue and relief in Paducah in 1937. The flood arrived with surprising speed. On January 19, Charles G. Vahlkamp, chairman of the Red Cross, appointed emergency committees. The next day refugees were housed in the old Southern Hotel at Second and Broadway. Water had closed Jefferson Street at First Street. The river was at 51 feet by this date.

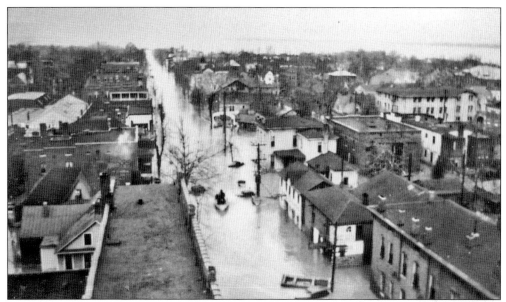

Looking westward on Kentucky Avenue, the flood seemed to have no end. In fact, the Red Cross and the U.S. Army built a dock and floating walkway across from the Twinkling Star Restaurant at 3100 Broadway that marked the end of high water. Pete Fowler broke a window at Peacock Garden with a pistol and converted the site into a relief canteen that served 41,000 meals to over 150 workers.

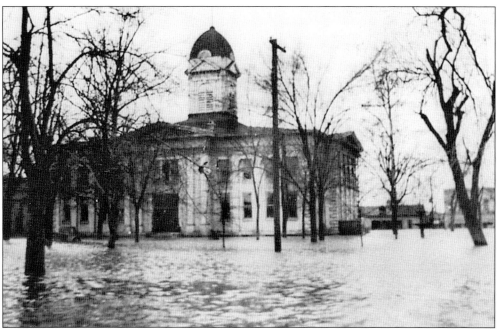

For a time, families on the South Side tried to find sanctuary in the county courthouse. As one remembered it, part of one family decided to go to the courthouse, "not knowing the condition the place was in." When water reached the treatment plant pumps, pressure was shut off. Shortly thereafter, no water to drink or flush the toilets in the courthouse made life intolerable. Other accommodations were desperately needed.

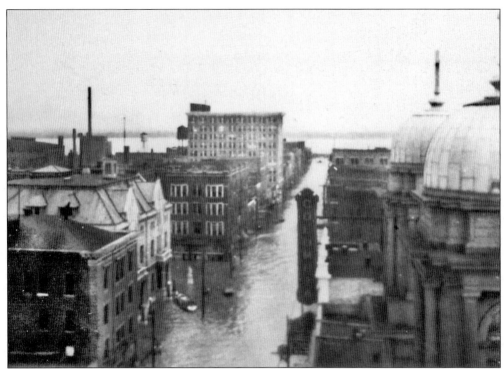

This view of the 1937 flood from the roof of the Irvin S. Cobb Hotel shows the post office on the left with the boat tied up and the statue of the legendary Chief Paduke with his feet wet. Further down on the left are the Palmer Hotel and the Citizens Savings Bank, which replaced the City National that went under in the Depression. The Columbia Theater is on the right.

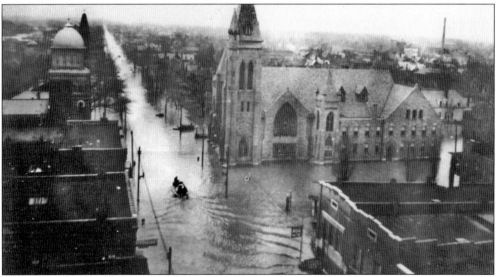

West from the roof of the Cobb Hotel one sees a boat approaching the Temple Israel on the left and Broadway Methodist Church on the right. Just behind the Temple lie Grace Episcopal Church and Carnegie Library. For a time, towboats with barges actually used Broadway as far west as Tenth as a channel. Stalled hulks of automobiles did make navigation tricky as they rose and fell with the currents.

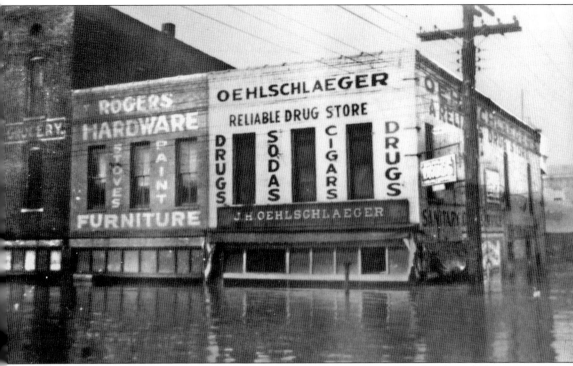

The Oehlschlaeger Drug Store at 1201 Broadway tried to ride out the flood until the army moved in and ordered the evacuation of the flooded area. In fact, the store introduced a new feature to marketing: row-up service. Boats would approach and yell for delivery. Mr. Oehlschlaeger would then open the second floor window, ask what brand of whiskey was needed, fill the order, and lower it down in a bucket. Initially, both parties were satisfied with the new arrangement; however, Oehlschlaeger soon learned to ask for pay first and delivery later. Unlike modern merchants, no security cameras were present to deter the "row-away" miscreants. John Oehlschlaeger's 35mm Zeiss camera only had a 50mm lens, not a telephoto.

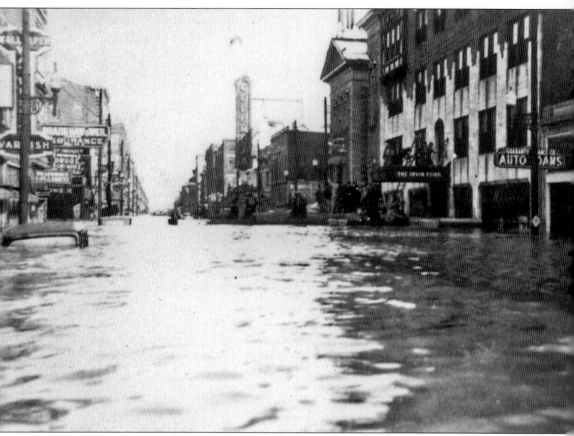

This view from in front of the Cobb Hotel looking toward the Ohio River illustrates the hazards to navigation caused by abandoned automobiles in Paducah. The flood came with surprising speed. Dr. Robert G. Matheson, head of Paducah Junior College, was attending a banquet at the newly opened Ritz Hotel honoring W.C. Johnstone, a beloved agricultural agent for Western Kentucky. Matheson had no trouble going out to Twenty-Second and Broadway; however, the return trip proved to be most difficult. His vehicle stalled but a passing taxi pushed him out; he got it restarted and managed to get home where he drove the vehicle up on a pile of ashes to elevate the vital engine parts. The weather turned bitterly cold and many vehicles stalled, never to start again as the flood engulfed them. The derelicts remained as a threat to passing boat traffic, rising and falling with currents.

Businesses at Fourth and Broadway sit idle and polluted by the flood. Sunday, January 24, Walter L. Beasley Jr. wrote in his diary, "Our chief concern is keeping well. We are all tired but are carrying on by strength. We are continually bumping into one another and running about through the house. The children are crying and the rest of us are so upset and excited that we are irritable."

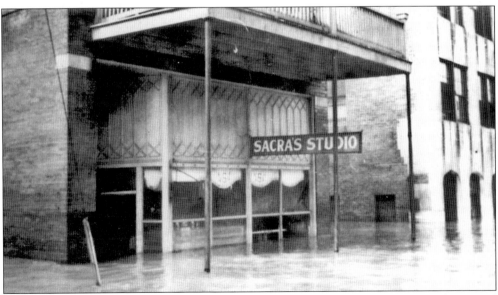

The Sacra Photographic Studio located in the front of the Irvin S. Cobb Hotel on the ground level shows the level of the water early on. For a time, the city authorities tried to continue occupancy of the upper floors as electric power was still on. Police and fire personnel were stationed there. The loss of the water treatment plant and the pumps on the sewers forced reconsideration for sanitary reasons.

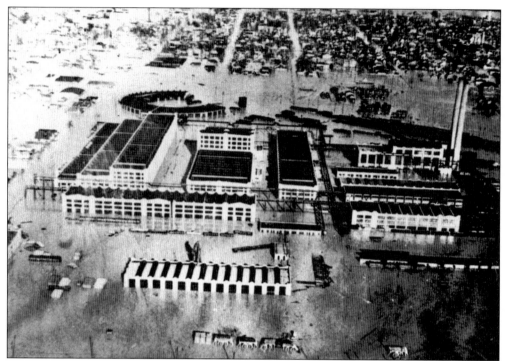

This aerial photograph of the Illinois Central Railroad shops puts the magnitude of the disaster into perspective. The roundhouse was on Thirteenth Street. Frank Jones left his job as foreman on the Illinois Central Railroad at 5 p.m. on January 19 only to have his car swamped and killed at Twenty-Third and Kentucky. A truck pushed him through but he had to walk home to Lone Oak.

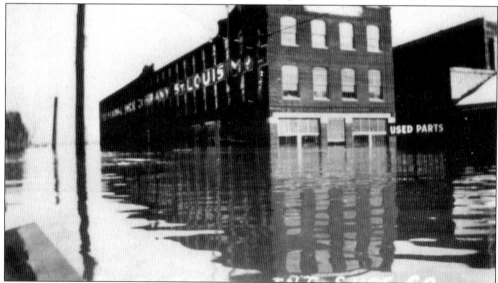

Flooding of the International Shoe Company at 128 North Second Street put its workforce out for the duration. The west of Paducah became a refugee camp with temporary city offices, hospital, and food kitchens serving those fleeing to higher ground. The army and Red Cross evacuated over 20,000 people from Paducah. Sites with flood refugees, such as PJC, were cleared. Anyone in the flood area had to have a pass.

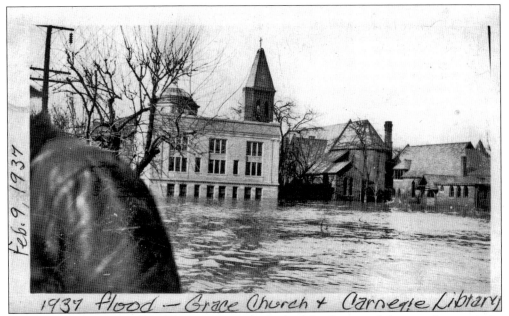

Feb. 9, 1937

1937 flood — Grace Church + Carnegie Library

This photograph donated by Judy Bray shows the back of the Carnegie Library with water in its basement and ground floor. Also visible is Grace Episcopal Church, equally beset by the flood. Most of the holdings of the library survived, but structures continued to have problems for years to come as wiring, equipment, and structural integrity was compromised. In particular, furnace boilers had to be dried carefully to avoid explosion.

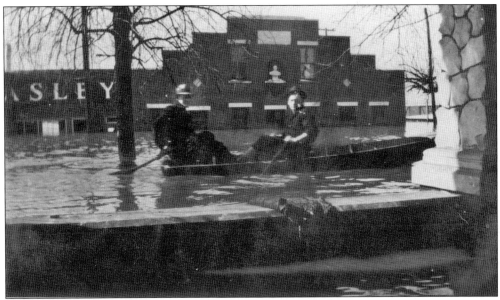

On January 25, W.L. Beasley Jr. recorded that "the water is rising about an inch every hour." On January 30, Beasley wrote, "It is now about 59 feet deep. A passerby has just told us that 150 troops will be here tomorrow to force everyone to evacuate in the interest of health." Beasley and his older brother Joe rowed about two miles the next day and caught a ride to Mayfield.

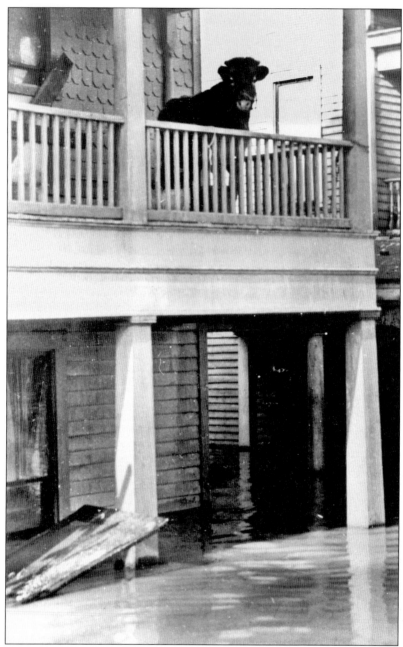

One of the most remarkable and reported incidents during the 1937 flood in Paducah was the story of the cow of the second floor of a porch. Jim Huston needed to get his milk cow out of the flood and hit on the idea of putting her on the porch. The only problem was the cow did not agree with the concept. Barron White, in My *Paducah: From the Early Years to the Present* (McClanahan Publishing House, 2002, pp. 82–86) gives the solution as Huston reported it later to his daughter. Huston grabbed the tail, pinched it double in the middle, and had to hang on as the critter bolted up the steps, across a landing, and on to the second floor. *National Geographic* made the incident widely known in its June issue of that year. Huston fed and milked the cow each day. A kinked-tail cow was the only lasting memento.

In 1981 students at Andrew Jackson Elementary School did an oral history project on the 1937 flood. Mrs. Haleen Wynn, then 84, told her interviewer that her family tried to wait out the rising waters like in 1913 but had to leave when the water actually got into their house. She remembered passing under the street light at Tenth Street, looking up, and thinking she could touch the light with her hand.

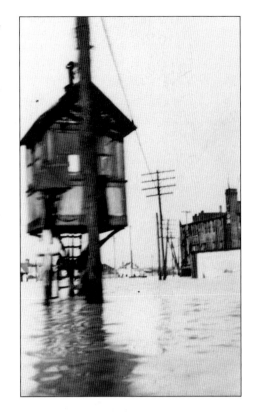

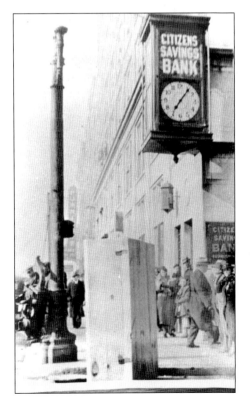

The flood forced many to reconsider social norms. Refugees found themselves in unsanitary situations at times. Even after the water receded, it was some time before things returned to normal. A case in point is shown here: people returned to their jobs downtown before the pressure was restored on the sewers. Temporary toilets were put over open manholes like this one at Third and Broadway. They were called "secretaries."

Once the waters abated, public pressure grew at a town meeting February 19. Two days later, a mass meeting was held to consider constructing a levee system around the city to prevent another incident and a petition was sent to Congress to aid in the estimated construction cost of $5.3 million. World War II delayed the completion of the floodwall, as steel was not available for the gates until 1946.

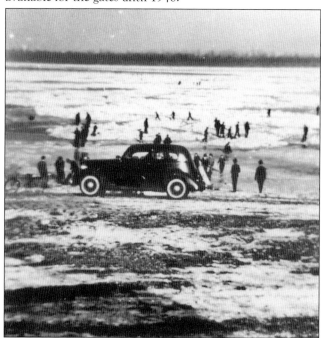

In 1937 flood was not the only plague to hit Paducah and vicinity. The Ohio River froze upstream, threatening the new highway bridge between Henderson and Evansville. Towns further downriver dreaded what the blockage would do when it melted and made its descent on the already flooded area near Paducah. The area near the "chute" on the Tennessee River did freeze, but no further significant damage resulted.

Six

EDUCATION

Private schools dominated education in Paducah until 1864, when two public schools began operation; that number doubled by 1881. Paducah High School graduated four students in 1873. For years, Augusta Tilghman High School enjoyed a reputation for excellence in both academic and athletic achievement. Paducah also was fortunate to have excellent opportunities for pupils attending St. Mary's parochial school, starting in 1856. At the turn of the 19th century, Draughon's Business School specialized in preparation for entry into the work force. West Kentucky Industrial College began training African-American teachers for Western Kentucky in 1909. Paducah Junior College began in 1932, absorbed West Kentucky Technical School, and replaced much of the private business training in the Paducah region as West Kentucky Community and Technical College. Today, a four-year accredited engineering education is available via the University of Kentucky at this site. Murray State University offers baccalaureate and master's degrees at the Crisp Center. Paducah Technical College continues the tradition of private skills training. Lately, K–12 programs have emerged at the Paducah Christian Academy and Victory Christian Academy. Home instruction also has increased in recent years.

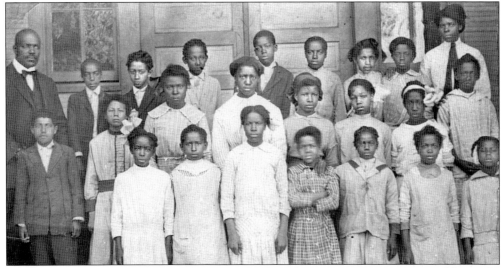

Education came to African Americans in Paducah with Union troops in 1861, and later, the Freedman's Bureau came as well. African-American public schools began in 1873. In 1881, education in Kentucky was consolidated under the Superintendent of Education. Dr. D.H. Anderson opened West Kentucky Industrial College as a normal school in 1909. Facilities and equipment usually were inadequate until Gov. "Happy" Chandler affirmed the end of segregated education in 1956.

Garfield was the African-American elementary school located at Ninth and Harris Streets.

Jefferson Elementary was at Eighth and Harrison Streets.

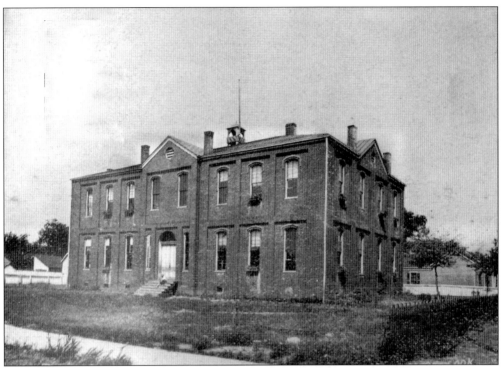

Robert E. Lee Elementary sat at Fourth and Ohio Streets.

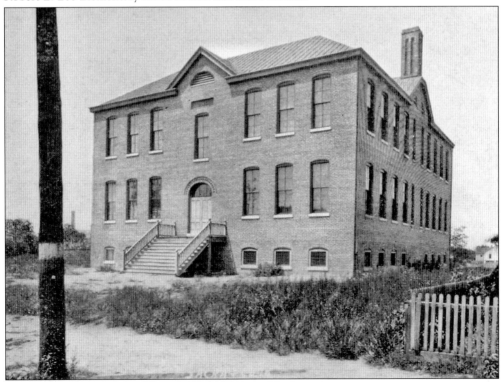

Longfellow Elementary was located at Twelfth and Jackson Streets.

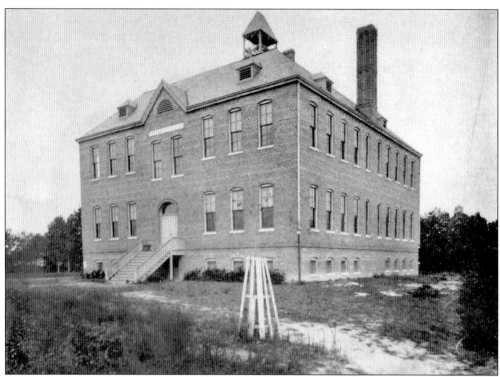

McKinley Elementary served the South Side at Hays Avenue and Bridge Street.

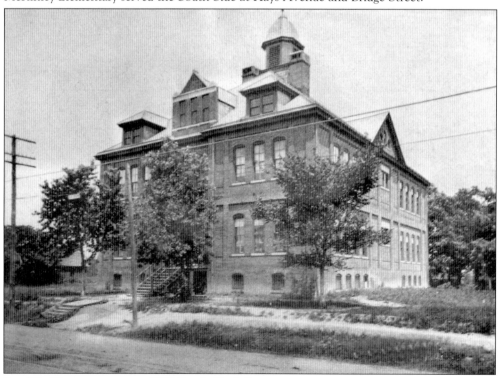

Franklin Elementary was at 1350 South Sixth Street.

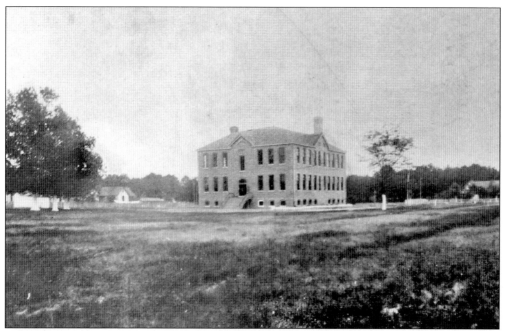

Whittier Elementary was on North Tenth Street.

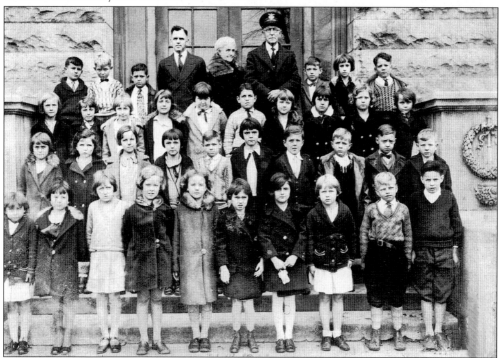

Washington was on Broadway and served as a high school, a junior high school, and an elementary school. The third and fourth grades are shown here in 1929. The principal was D.T. Cooper, the teacher was Miss Rose Flournoy, and the policeman is John N. "Daddy" Hessian. Among those pictured is Birdie Elizabeth Sullivan Brown, eight years of age. Elizabeth is in the front row, fourth from the left.

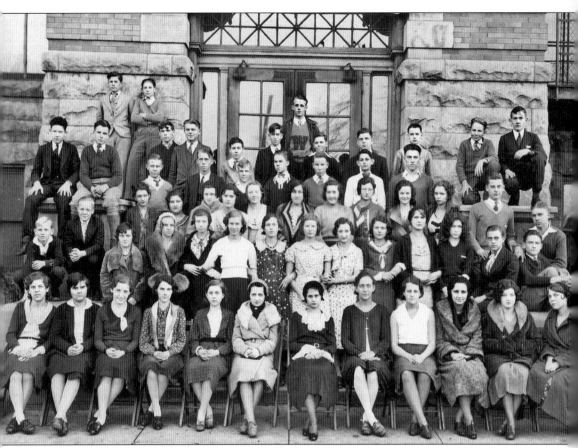

Washington Junior High School in 1931 still reflects the prosperity present in Paducah through the 1920s. Construction of a Firestone Store downtown and of Heath High School in the county spurred the local economy. On November 29, 1929, the recently paved south side of Jefferson Street was opened for traffic from Twenty-Eighth to Thirty-Second. True, there were signs of the crash to come. First National Bank was in disarray as was Mechanics and City National. Conditions worsened in early 1930, as the Great Depression arrived on the banks of the Tennessee and Ohio. The headquarters of the WPA for western Kentucky was located in Paducah. Work, not charity, was available but not rewarding. Still, the clothing of the students at Washington reflects the general well-being of Paducah at the start of the prolonged period of hard times.

Compare and contrast the clothing of this class at Washington Junior High School in 1936 with the class of 1931. Wear and tear is evident.

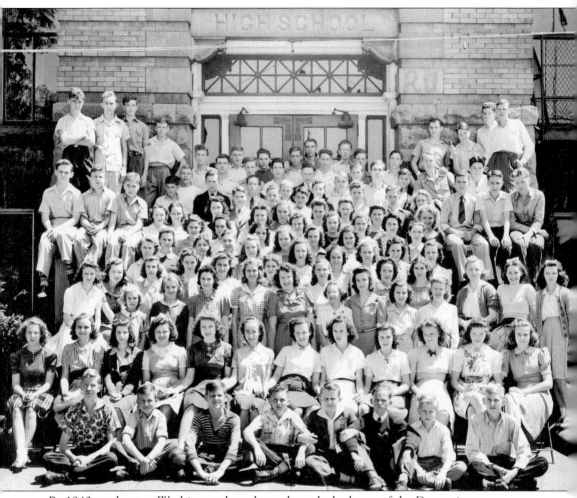

By 1940, students at Washington have been through the brunt of the Depression.

Kindergarten in 1929 was an exciting new experience for children and parents. After 1873, Susan Elizabeth Blow of St. Louis was influential in spreading the kindergarten movement in the United States. Patty Smith Hill, who wrote the tune "Happy Birthday," made a similar impression in Louisville. Thirteen students completed the program at Andrew Jackson School in Paducah. Bertha Wheeler Wenzel is the last pupil on the right.

Jackson Kindergarten in 1956 gives an appearance similar to that of the 1929 program. Public preschool programs such as this one seldom survived the Great Depression. For a time, preschool programs were relegated to the private sector or to various church programs such as that of St. Paul Lutheran, which replaced their elementary school. Some preschool programs were more baby-sitting than educational.

First aid was an important part of the curriculum, as was the Safety Patrol. Members of this elite group got to wear white Sam Brown belts with an identification tag. Barron White and Ludell Leonard Paul both fondly remember the unofficial sponsor, John N. "Daddy" Hessian. This Paducah policeman was assigned to the Washington Junior High School where he also served as a friend and able protector of the children.

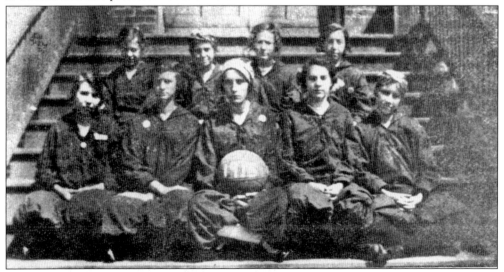

In 1915 high schools were relatively rare, and so was the concept of women in athletics. Nevertheless, these daring young women bravely faced the camera clad in their sports regalia designed by Elizabeth Smith Miller along the lines of Turkish pantaloons with knee length skirts. Amelia Bloomer saw this costume and popularized its use by young women in *The Lily* after 1849. Women's basketball focused on getting into position and passing.

Lincoln High School was at Eighth and Ohio Streets and served the African-American students in Paducah.

Paducah High School was located on West Broadway and served until 1919. Frederick and Sidell Tilghman returned to Paducah and offered to furnish a lot for a new high school to be named in honor of their mother, Augusta Tilghman. High school students canvassed the city to seek support for the new school in the fall election. Women voted for the first time with 2,291 of the 4,940 votes cast.

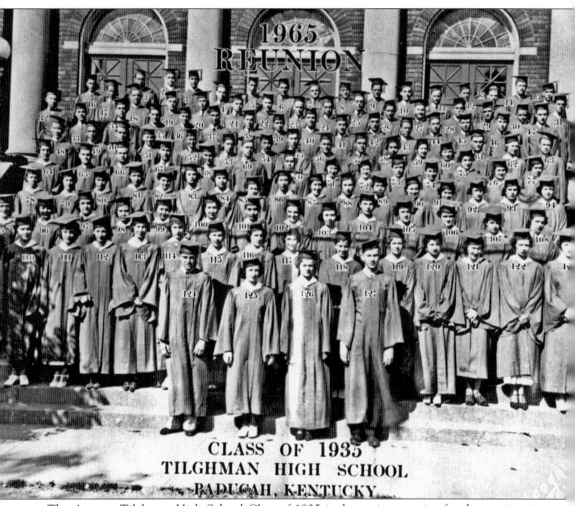

The Augusta Tilghman High School Class of 1935 is shown in a reprint for the reunion in 1965. Walter L. Beasley Jr. is at left on the front row. One wonders why the women to the viewer's left did not follow the lead of the others and fold their hands.

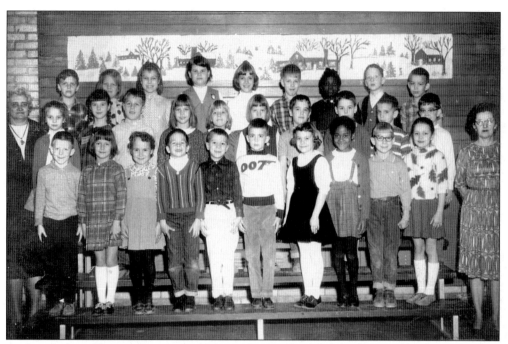

Andrew Jackson Elementary principal Minnie Lee Ragland, left, and Nannie Heflin, right, pose with the second grade class of 1965–1966. This was taken just before integration began in Paducah Public Schools.

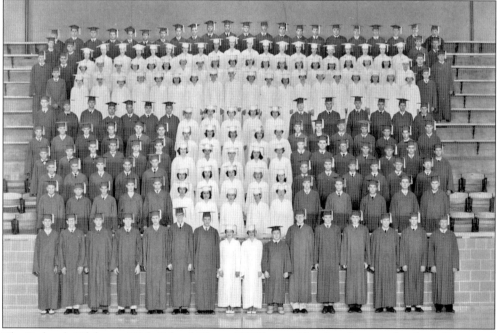

The Paducah Tilghman High School Class of 1957, posed for the photographer from Curtis and May studios as an appropriate *T*, marked the watershed between the old Augusta Tilghman with its years of tradition and the new Paducah Tilghman. The first class to graduate in the new school was in 1956 and the first to complete all three years at the new school graduated in 1958.

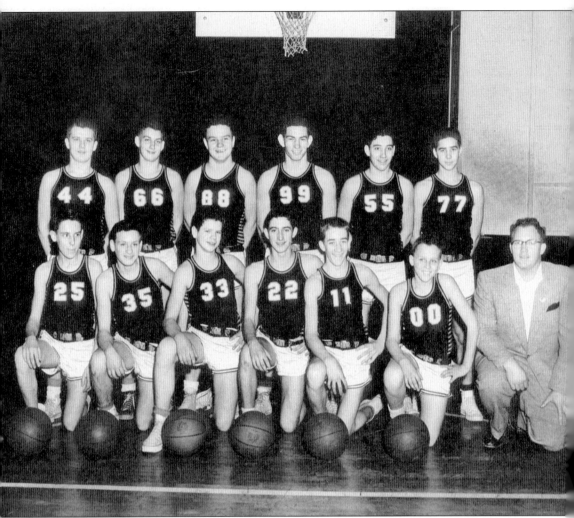

The 1954 ninth grade basketball team of Washington Junior High finished the school's final season without a loss. This champion team consisted of, from left to right, (front row) David Parks, 25; Buddy Nanny, 35; Larry Hooper, 33; Jerry Edwards, 22; Dick Throgmorton, 11; Tommy Overstreet, 00; and Coach Duane "Red" Nichols; (back row) Terry Hargrove, 44; Otis Denning Jr., 66; Stanley Sarger, 88; Bob Taylor, 99; Roy Bryant, 55; and Charles Evers, 77.

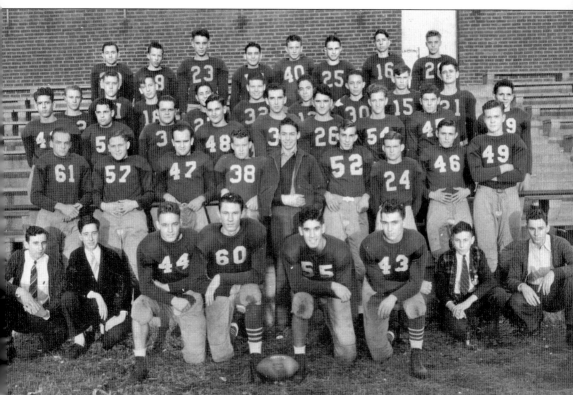

For many, the 1937 football team of Tilghman High School ranks at the top of the memorable teams coached by Coach Ralph McRight. Prior to coming to Paducah, McRight had attended the University of Alabama and played in the Rose Bowl. While coaching at Hopkinsville, McRight lost to the Tilghman team led by Coach Phil Beverly, who had switched center William Black to quarterback for the game because of injuries. The next year at Tilghman, McRight put Black back as quarterback, a move that justified itself by Black being named first-team all-state at that position. The 1937 season started off badly, Tilghman losing to Evansville Memorial 34–6. Billy Hillendbrand, later all-American at Indiana, led the Memorial team. Tilghman's second loss was to St. Xavier of Louisville 18–6. Tilghman won eight games, including the trouncing of Mayfield 21–6.

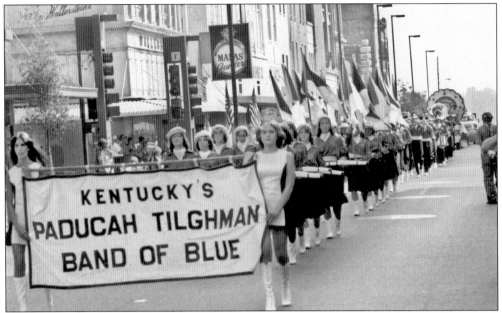

Directors of the Tilghman band were John H. Dameron, 1928; Floyd Burt, 1930–1943; Paul C. Brake; and C.W. Coons, 1944–1945. The next 25 years were under Burt, who left a lasting legacy of excellence. Then came Roger Reichmuth, Al Farrell, Reichmuth again, and T. Jack Henry. Shelton returned for the 1975–1976 year and was replaced by Doug Van Fleet in 1976. This Labor Day parade c. 1983 shows the uniforms of the period.

Paducah Middle School spring band concert held in 2002 drew a packed auditorium. The music was challenging, reflecting the advance in music education that permeates the public school system, with introduction in the elementary, application in the middle school, and performance level presentations in high school. Music is not limited only to brass and wind instruments. Competitions allow the musicians to test their skill with their peers across the state.

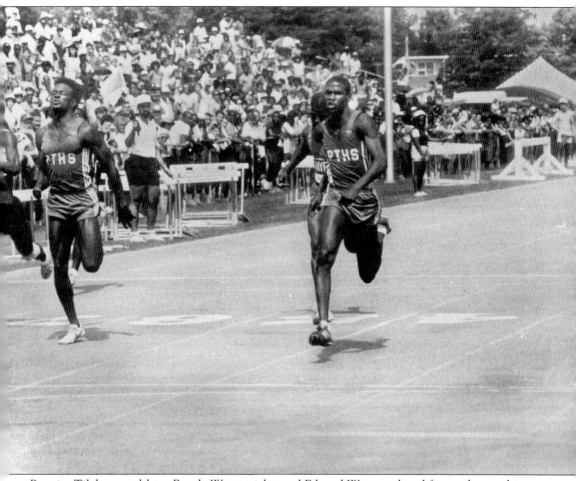

Premier Tilghman athletes Randy Wyatt, right, and Edward Watson placed first and second in the 100-meter dash as eight graders at this state championship in track. Wyatt also won the 200-meter dash; no one had ever won both the 100-meter and the 200-meter dashes before. Now Tilghman's track coach, Wyatt coached Tilghman's track team that lost to Fort Campbell on a disputed decision in 2000. Since then, Wyatt's Tilghman team has won the last four track state championships.

Established by the Catholic Sisters of Charity *c.* 1858, St. Mary's Academy continues to provide quality education in Paducah. During the Civil War, the sisters also served as nurses after the Battle of Shiloh. The school moved to the west side of Paducah on Elmdale Road in 1965 as St. Mary and now offers PK–12 classes with inter-parochial support. The institution is under the auspices of the Owensboro Diocese.

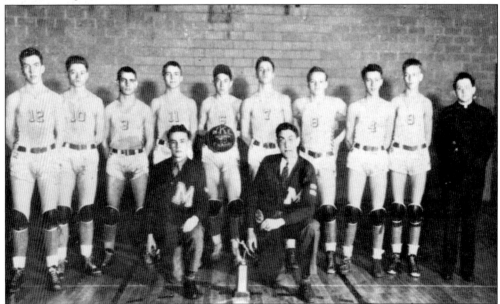

The Knights basketball team of St. Mary's Academy poses with its championship trophy in 1943. After consolidating several small schools into a larger entity, St. Mary, it was expedient to change the name of the school mascot. The new title adopted in 1965 was the Vikings. Today, St. Mary has an enviable record in track and field, especially in cross-country competition, and it maintains its heritage by fielding a strong program in basketball.

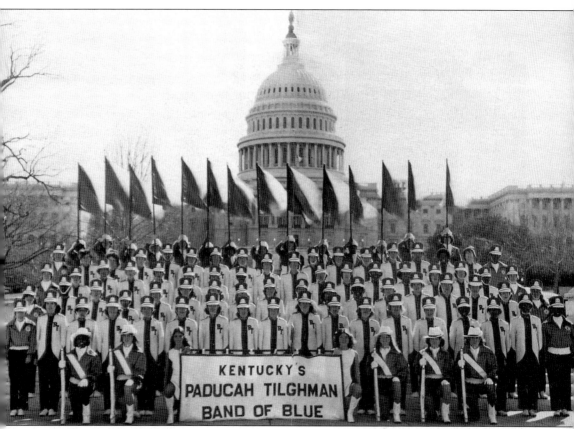

In 1978 the Paducah Tilghman Marching Band journeyed to Washington, D.C., to participate in the annual Cherry Blossom Festival. Upon arrival, the blossoms were not fully matured; however, the event proved most memorable. In particular, the weather provided a severe trial for all members. It was cold and windy throughout the parade route. Director Doug van Fleet was shocked to note that often the girls carrying the flags were literally knocked over by the wind. The sousaphone players also experienced major difficulties as the bells acted like sails in the gale-force winds. The winds tended to nullify the effect of the music as it was whipped away from one side of the avenue and blasted the other and then echoed again. Rep. Carroll Hubbard made up for the difficulties of the march by taking the band onto the floor of the House of Representatives. They even got to stand behind the Speaker's platform. All in all, the trip was a memorable event.

GRADUATING
1938

A teacher-training school for Kentucky, now Kentucky State University, was established in Frankfort in 1886. In 1909, Dr. D.H. Anderson, middle row center, dug the foundation for West Kentucky Industrial College in Paducah. Funds were collected from door to door. In 1912, Anderson petitioned the Legislature for funds and got $17,000. In 1913, an article in the local paper brought additional funds and the City also contributed. Persistence by Anderson paid off in 1918 when Gov. A.O. Stanley signed a bill providing $3,000 per year and $5,000 for improvements. By 1938, all college courses were sent to Frankfort and the Paducah school became a post-secondary technical campus. In 1977 Gov. Julian Carroll, a Paducah native, provided funding for a new campus on Blandville Road, and Paducah Junior College Inc. donated land. In 2003, the technical school merged with Paducah Community College to form West Kentucky Community and Technical College.

Paducah Junior College opened at 707 Broadway in 1932 in the house formerly owned by Dr. David G. Murrell, the chief physician of the Illinois Central Hospital at 1423 Broadway, and the J.E. Bugg family. In 1926 the structure housed the YMCA, which added an indoor swimming pool, the largest west of Louisville at the time. After World War II the college added the new section on the west side.

In Paducah, Dr. Robert Gordon Matheson is "the Dean." Under his leadership, the struggling Paducah Junior College survived the Great Depression, 1937 flood, World War II, and the burst of growth in the 1950s that forced the school to move from downtown to its present site. Matheson guided the school to full accreditation with the Southern Association of Schools and Colleges and a merger with the University of Kentucky.

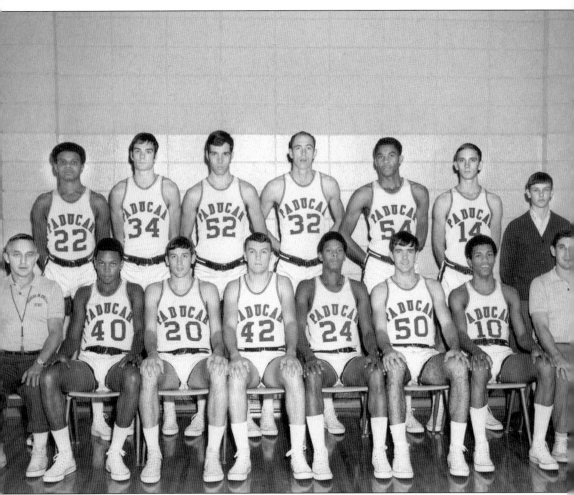

Paducah Junior College participated in intercollegiate athletic competitions. Having an indoor pool, the school was a natural home for swimming. Baseball teams could use the facility built for the Kitty League Indians team. The school was one of the first to field a coed team (in rifle competition) in intercollegiate competition. In 1969, as Paducah Community College, the school won the national Junior College Basketball Championship under coach Claude "Sonny" Haws and assistant coach Jimmy Don Peck. The team members are, from left to right, (front row) Coach Haws, 40 Jim Johnson, 20 Mike Young, 42 Dan Hicks, 24 Bobby Jones, 50 Billy Boyd, 10 Rex Baily, and Assistant Coach Peck; (back row) 22 Haywood Hill, 34 Rick Ragland, 52 Tom Yachinich, 32 L.H. Tyler, 54 Lannie Jones, 14 Gary Sundmacher, and manager Joe Demsey.

The families associated with Paducah Junior College, including faculty, maintenance, and students, used to meet for picnics, "watermelon busts," and other social functions. When the college moved to its present location in 1965, that tradition carried over for several years at Paducah Community College. This occasion was an Easter egg roll for children. The western side of Carson Hall, the administration building, was relatively wild.

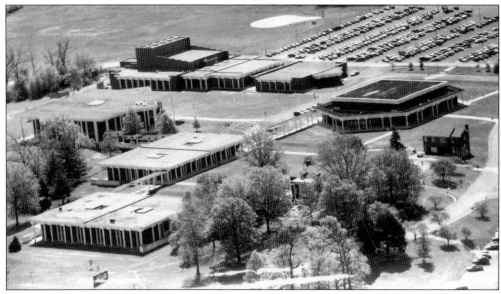

This 2003 view of Paducah Community College illustrates the growth potential. Moving to Blandville Road allowed the school to more than double enrollment. The theatre-student center brought art to the campus. Land was donated to the vocational school and an Allied Health complex expanded the nursing and other allied health programs. The two institutions combined into the West Kentucky Community College and Technical School. The University of Kentucky College of Engineering complex and the NASA center expand the service area of the school.

While campaigning against Bill Clinton, President George Bush drops in at Paducah Community College to catch motor-transport for a tour of the area. His rival followed him to Paducah and spoke to the media and interested voters from Barkley Airport, taking advantage of a slip Bush had made about the name of the community. Clinton made certain everyone understood he knew he was in Paducah.

Dr. Michael McCall, head of Kentucky Community and Technical College System, and Dr. Barbara Veazey, president of West Kentucky Community and Technical College, lead the first graduating class into the Julian Carroll Convention Center. The site was apt, as Paducah resident and former governor Carroll graduated from PJC, taught for PJC and PCC, and served on the Board of PJC.

Seven

REINVIGORATION
1950–the Present

Beginning with Project Town Lift in the 1950s, the downtown area of Paducah experienced a renaissance in appearance and purpose. Overhead wires formed a spider-web across the entire downtown area until a 1954 initiative put them out of sight. Merchandising moved to the mall on the western edge of the city while downtown shifted to other uses. Unlike many cities, Paducah never allowed its core area to become a slum. Efforts to redeem and re-create the area continue. Lower Town was the first to pull itself up by its bootstraps. That incentive continues today with the Artist in Action program, which encourages artists to buy city-owned properties in decaying areas and renovate them into homes, many with studios. The result serves as a national model and continues to attract a diverse and creative coterie of artists.

George Katterjohn Jr., Jennifer Leigh, and Rebecca Meade Beasley helped dedicate the time capsule buried on September 6, 1956. Various articles were selected and secured in the monument to allow future generations to get a glimpse of life in Paducah mid-way though the 20th century. It will be interesting to see the reaction of those in 2005 when the contents are recovered. Life now is so much busier and more dangerous.

New members joining Beta Sigma Phi sorority were honored at the annual spring banquet held in the Irvin S. Cobb Hotel in 1954. This organization is an international cultural and social organization for women formed in Kansas City in the 1930s, and it continues to be an active part of the community. Like most organizations in Paducah, membership has declined from the boom associated with the atomic plant.

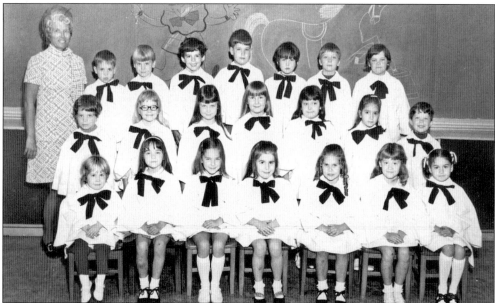

Private- or church-affiliated preschool education, such as this kindergarten class at St. Paul Lutheran Church, was typical of this level of education in Paducah until 1973, when kindergarten public education became available at Northside Elementary in a pilot program now extended to all elementary schools. Private instruction at St. Mary inter-parochial school, the Community Christian Academy, and the Victory Christian Academy commands a growing enrollment. Lately, home schooling grows.

Controversy erupted when it was obvious that Paducah needed a new city hall. Two floods took their toll on the building erected in 1883 and the third story added in 1909. Many wanted to move the city hall west to keep up with the shifting population. Tom Wilson led a campaign to keep the structure in the downtown area and was elected mayor in 1963 by assuring the present location.

Paducah's city hall, designed by noted American architect Edward Durell Stone, is a duplicate of Stone's American Embassy in New Delhi, India. The structure complements the core area of the city and is connected with the McCracken County courthouse by a plaza, complete with tiered walks, benches, and a wonderful fountain that eases the summer's heat. The area serves as the center of the summer festival begun by Mayor Wilson.

Paducah's Summer Festival took over much of the area near the river initially. It quickly drew attention nationwide. *National Geographic* did a feature on the event in June 1973. Among the early events was this "drop in" by soldiers from the 101st Airborne Division from Fort Campbell. The group landed perfectly before a packed crowd on the riverfront. Originally, events ranged from watermelon-eating contests to climbing a greased pole.

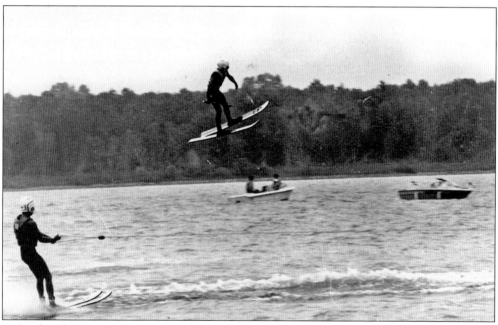

Paducah's Ski Nuts club had a practice course located on the east side of city just off I-24. The Summer Festival provided the club an opportunity to share its skills with the crowds at the foot of Broadway. In addition, an annual swim across the Ohio attracts others with aquatic skills. A boat to ensure safety accompanies each swimmer. This event is memorialized in the mural on Kentucky Avenue.

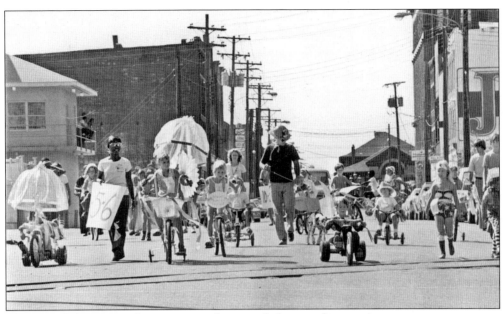

Planners of the events downtown sought to include something to interest most age groups. Obviously most events are aimed at teen and adult participants and attract the greater number of contestants. However, even the pre-school generation exercised its right to parade. Events include races, hula-hoop contests, and more. The length of the track is smaller but the intensity of the competition equals that of the adults.

The railroad industry had been the principal employer in Paducah up to the 1960s. The shops were among the largest in the world. The Illinois Central Railroad routinely shipped 225 hopper cars, each carrying 70 tons of coal, from West Yard in Madisonville to Chicago and returned the empties in unit trains with seven diesel engines and a caboose. The telegrapher operator routinely delivered train orders to the speeding train engineer as shown.

Funland at Noble Park was a Paducah institution for decades. Rides, including a miniature train that circled the park, delighted generations of Paducahans. Teenagers dared each other to risk the Whip and other rides. The special attraction of the park in the summer was the large swimming pool. When the rides left, the park fell into decline. Mayor Geraldine Montgomery redeemed the site and made it a community treasure.

Roger Kellner identifies this Shrine minicar group parading on July 26, 1975 as, from left to right, Joe Walker, Kelly Joiner, Ralph West, and Hubert Jackson, captured as they passed before the Irvin S. Cobb Hotel. The drivers, bulging out of their miniature cars, dashed madly in and out, around and about, to the delight of the massed spectators. The same day as the parade, the Jackson House senior citizen residence was dedicated.

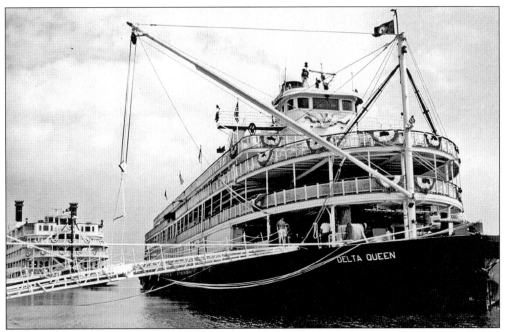

The *Delta Queen*, the *Mississippi Queen*, and their newer and larger sister, the *American Queen*, are regular visitors on the riverfront in Paducah. Each visiting craft is welcomed by the Paducah Ambassadors, clad in red jackets and smiles. The Paducah Tourist Bureau arranges guided tours. Some of the boats have theme tours and traveling scholars. In Paducah crowds welcome the craft, help them enjoy the city, and wave them farewell.

During this summer festival and the Arts in Action show, Broadway downtown became a pedestrian path, and booths and exhibits lined the route. Crowds meandered from point to point casually, enjoying the antique automobiles parked along the route. It was as if the city had taken time out from the hurly-burly of 21st-century American life and just decided to enjoy a warm day and good company. The moment is remembered.

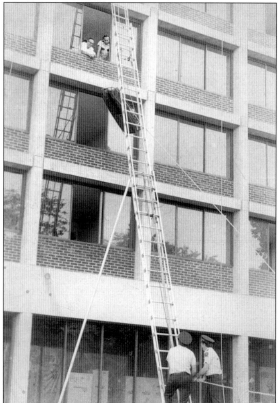

Alben Barkley coined the term "New Deal" in the keynote speech at the Democratic Convention in Chicago in 1932. He was a favorite of President Franklin Roosevelt and was Harry Truman's Vice President in 1948. The oldest man to take that office, Barkley also married for the second time in 1949 to Jane Rucker Hadley of St. Louis. The "Veep" is shown, from left to right, with daughter-in-law Dorothy Barkley, Paducah attorney James Wheeler, and son David Barkley.

The Jackson Apartments at 301 South Ninth forced the Paducah Fire Department to rethink its safety training. Previously, the 10-story bank at Third and Broadway was the tallest structure in the area. Built by the Western Kentucky Senior Citizens Union Labor Housing Corporation in 1971, the 20-story apartment structure soared beyond the highest ladders. A conference hosted by Paducah Junior College brought in a panel of national experts to assist in training to meet the new conditions.

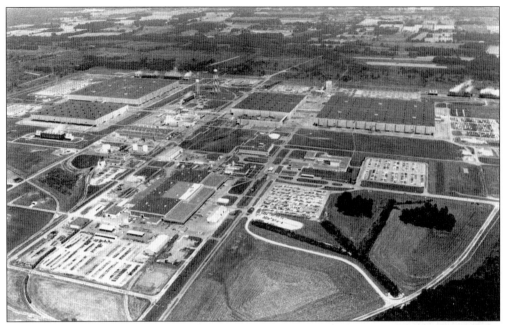

The day after the Chinese crossed the Yalu River in North Korea, sending UN forces toward the sea, the decision was made in Washington, D.C., to build a gaseous diffusion plant at Paducah to supply enriched uranium for atomic bombs. Paducah's population doubled. The plant, 50 years later, is a mainstay for the economy of Western Kentucky but is being phased out.

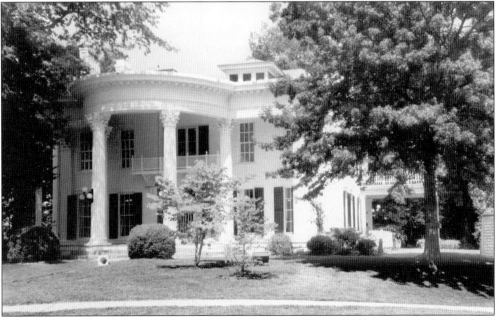

Whitehaven welcomes travelers on I-24 coming from Illinois to Kentucky and bids those crossing the state from Tennessee adieu. Kentucky chose to restore an historic building rather than razing one to put up a concrete box that is functional but lacks a sense of style. The antebellum Smith House was only hours from demolition when Gov. John Y. Brown rescued it and restored it.

Starting with Project Town Lift in 1977–1978, Paducah, like this view from the top of the bank at Third and Broadway, looked to the west. Note the absence of overhead power lines. Brick sidewalks and new lighting changed the physical ambiance in the downtown area as trade and commerce fled to the western limit and took root in the giant Kentucky Oaks Mall. Completion of Interstate 24 helped the mall area.

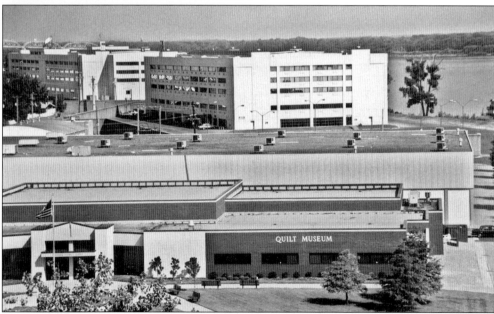

The museum of the American Quilters Society houses a remarkable collection of quilts ranging from folk art to modern marvels of design and color. In addition to the regular collection, the museum hosts traveling exhibits from various depositories, such as Shaker work. Each year the organization has an annual show in Paducah and the winners take home thousands of dollars and, as important, the accolades of their peers. Thousands attend.

Every town, large or small, has a gathering spot. One of Paducah's is G and O Drug Store. The store maintains its fountain and specializes in dishes unique to the community, such as the "Full House," for over 50 years. Certain stools or tables are locally recognized to be reserved for certain patrons when coffee and banter flow. In addition, the store still delivers.

The various fraternal orders continue to play a vital role in the life of Paducah and the surrounding community. Here the Masons recorded the inauguration of a new master of the lodge in December 1995. The Masons, from left to right, (front row) Ronnie Crenshaw, Bill Rayborn, J.D. Joiner, Master Sam Jackson, Don Krone, and Wes Smith, along with other unidentified members of the lodge pose for the camera in celebration of the event.

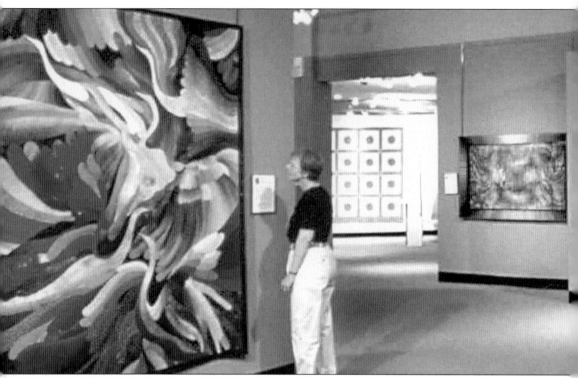

The holdings of the Museum of the American Quilters Society feature a permanent collection that expands each year with the winner of the annual contest. The collection ranges from folk art, both local and from around the world, featuring delicately stitched, hand-cut pieces saved from family

Educational outreach endeavors by the Museum of the American Quilters Society include tours by area schools, such as these two views of elementary students from Cooper-

clothing materials, to intricate patterns fashioned by computer-generated software and put together on elaborate sewing and quilting machines. Care must be taken to assure that the samples are properly displayed and protected while also making them available to a broad flow of viewers.

Whiteside, on the South Side of Paducah. Craft skills are appreciated by a growing number of people worldwide.

There is a tradition in Paducah that the Ambassadors meet the touring riverboats and escort their passengers on tours of the city. The group is easily recognized, as they wear red jackets and never meet a stranger. When the time comes to say "Bye bye, *Queen*," the group gathers at the river to wave farewell as the steam calliope renders various tunes including "My Old Kentucky Home." Tears are not uncommon.

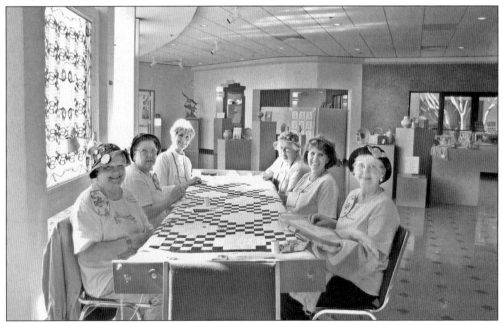

Charlotte Roberts, Virginia Hancock, Jewel Reid, Anita Manning, Pat Lewis, and Carolyn Carver constitute the "Yo-Yo Club," meeting on a regular basis at the Museum of the American Quilters Society in Paducah. Clad in dashing hats and yellow shirts, the members greet visitors while enjoying themselves and their art. Each year a quilt they design, put together, and stitch is auctioned during the Quilt Show for local charity.

118

After dinner on Saturday evenings from May to October, Broadway becomes a pedestrian path from Sixth Street to the Ohio River. In 2002 this group performed to crowds that brought their folding chairs with them and settled in to listen to their favorite music. Some wander from location to location; others choose to stay at one site for most of the evening. The entertainers range from soloists to sizable ensembles.

The McCracken County Courthouse was a WPA project during the Great Depression. Originally, the seat of the county was at Wilmington, nearer the center of the county. The site selected was subject to periodic flooding, so the seat of the county moved to Paducah in 1831. Originally located on Second and Kentucky, the courthouse moved to its present location in 1857 and lasted there until 1941.

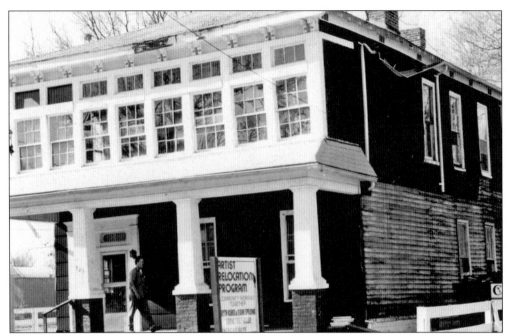

To date, 80 artists have relocated to Paducah as partners in the Artists in Action program. This program has attracted national attention. The city of Paducah helps match artists interested in relocating with sites in Lower Town at present, but the program is expected to move further west as demand continues to grow. Local financial institutions make funds available for this project at attractive rates. Many artists construct galleries along with restoration.

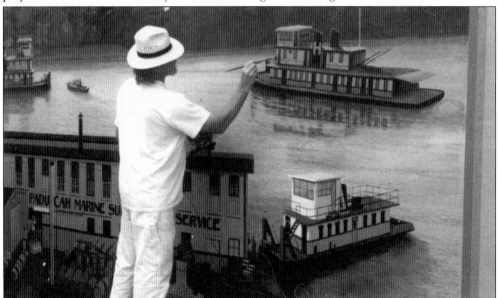

Robert Dafford may not be one of the Artists in Residence in Paducah, but his work is the most prominently displayed. Robert and his associates have made the murals on the floodwall into a community masterpiece. The Murals Committee, in consultation with Robert and company, must review each project. The Murals Committee approves a proposed picture only if the material is available, historically relevant, accurate, and compatible with *trompe l'oeil*.

In 1993 Oscar Cross received the Boys and Girls Club Herman S. Prescott Award. The Board of the Paducah Boys and Girls Club was the first in the nation to be integrated. The board is, from left to right, Berdus Brown, Tom Massie, Wilson Gunn, Curlee Brown, Regenaldo Donaldson, and Oscar Cross. Mr. Cross served youth for over 50 years. Cross was also the first juvenile officer for McCracken County.

As long as society in Paducah was segregated, each race participated in parallel social groups and patterns. In the late 1940s and early 1950s, the African-American community leaders often met in the house of Dr. S.L. Polk. Meanwhile, the white community leaders would be at the country club or in the home of some recognized person. The two groups seldom met other than in casual encounters.

Sea stories filled the air as veterans gathered to honor the visit of this living history exhibit. Ships like LST-325 were not an uncommon sight on the Ohio River during World War II. These vessels were fabricated in Evansville, Indiana, among other places. The vessels were reliable and rough and could cross the oceans and deliver cargo at water's edge. LSTs rode like roller coasters in a storm.

Throngs swarm the riverfront area during Summer Festival in July and the Barbeque Festival in September. Pedestrians slowly move shoulder to shoulder through the streets of downtown Paducah during the four-day April Quilt Show. Hotels for a radius of 70 miles are booked solid during the later event. Over 20,000 participants hailing from many countries make the trek to Paducah for the annual event. Downtown is alive again.

Paul Cissell, one of Paducah's Ambassadors, conducts a high school class on a tour of the murals on the floodwall. Robert Dafford, a renowned practitioner of *trompe l'oeil*, like Norman Rockwell and other realists gives his work a depth that is remarkable from a plane surface. One feels that one could enter into the work, not just observe it. The Murals Committee struggles to keep the material authentic and interesting.

Students from communities around Paducah regularly come to the riverfront to view the murals sanctioned by the Murals Committee and executed by Robert Dafford and company. The Tourist Bureau arranges for a guide to accompany groups and explain how each mural relates to the history of Paducah and Kentucky. It is not uncommon to the see the parking lot filled with buses transporting children ranging from kindergarten to high school.

Mary Hammonds of the Paducah Tourist Bureau pauses in front of the restored Kirchoff Bakery to explain the building's preservation to this group of visiting veterans. The present owners were descendants of the founders of the bakery. The location is a favorite spot for lunch among those working in the downtown area. Frequently it is standing room only in the bakery and patio areas, and wonderful aromas welcome visitors.

Paducah Junior College began in 1932 at the depth of the Great Depression. Initially private, the college received funds from the City in 1936 and from both City and County governments in 1963. In 1968, the school merged with the University of Kentucky's new Community College System. Under UK the college at Paducah won the national championship in basketball for two-year schools and also acquired a nationally accredited four-year engineering school.

The Gulf War, September 11, and the War with Iraq all contributed to the outpouring of recognition and thanks from Paducah to those who served in the armed forces. NBC's Channel Six TV personality Sam Burrage (standing), a veteran of combat in Vietnam, served as host of the gala and the entire riverfront was filled with well-wishers. David Bradshaw, seated, is a retired army sergeant major.

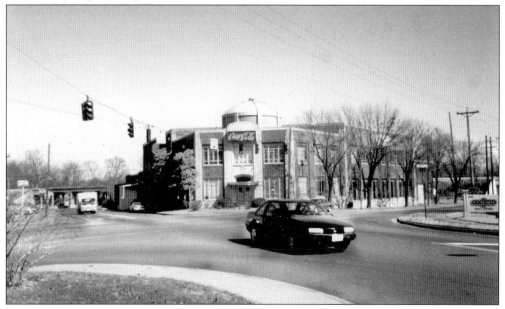

The Coca-Cola Building was built between 1937 and 1939 at the corner of Broadway and La Belle—the site of the western limit of the flood of 1937. A marble fountain (of Coke!) greeted guests.

Communities need keepers of the scrolls and preservers of the past—those dedicated individuals who preserve our memories and insure that each new generation does not forget the rich legacy left them by their predecessors. Such guardians of the art of Clio seek to memorialize their generation's accomplishments and foibles and pass them on intact to the following generations. Seen here from left to right are the author, Charles Cissell, Barron White (with cap), and Richard Holland.

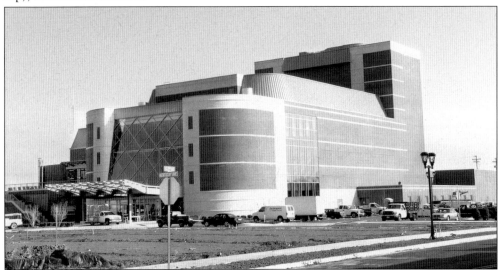

The Luther Carson Center for the performing arts opened to donors February 26, 2004. This imposing structure was to be the capstone to the progressive renovation of downtown Paducah, transforming it from a commercial center to a center for the performing arts and the home of the Paducah Symphony. Traditionally such functions had been presented in the local high school, churches, or the college.

Russ Cochran is one of the premier athletes from Paducah. A multi-letter graduate of St. Mary High School in 1976, Cochran earned admission to the mini-tour on the PGA in 1980 and got his ticket in 1981. Cochran was often among the top finishers and highest earners. He won the Western Open in 1991 in Chicago. Left-handed professional golfers are rare.

The River Heritage Maritime Museum is a recent addition to Paducah's places to visit. The facility opened in August 2003 with $1 million of state-of-the-art interactive exhibits including, shown here, the working model of a lock similar to Dam 54. Located in the oldest building in the downtown area, the new facility captivated Sarah and Janie Harris. Tours also include an hour-long ride on the *Chattanooga Star* in May.

Alben Barkley died April 30, 1956, while speaking in Lexington, Virginia. His last words were, "I would rather be a servant in the house of the Lord than to sit in the seats of the mighty," thus ending a long and illustrious career in politics. He served his state and nation with dignity and honor. Long a power in the Senate, Barkley had returned to that body in 1954.

Mt. Kenton Cemetery is the final resting place of Paducah's most widely known adopted son, Vice President Alben William Barkley, and many other Paducahans. Originally situated on the outer limit of the city in 1872, Mt. Kenton now lies encapsulated between Paducah and the rapidly growing Lone Oak village on busy U.S. Highway 45. Adjacent to Mt. Kenton is the Temple Israel Jewish Cemetery.